DORSET
IN PICTURES

MATTHEW PINNER

AMBERLEY

First published 2022

Amberley Publishing
The Hill, Stroud
Gloucestershire, GL5 4EP

www.amberley-books.com

Copyright © Matthew Pinner, 2022

The right of Matthew Pinner to be identified as the Author of this work has been asserted in accordance with the Copyrights, Designs and Patents Act 1988.

ISBN 978 1 3981 0693 2 (print)
ISBN 978 1 3981 0694 9 (ebook)

All rights reserved. No part of this book may be reprinted or reproduced or utilised in any form or by any electronic, mechanical or other means, now known or hereafter invented, including photocopying and recording, or in any information storage or retrieval system, without the permission in writing from the Publishers.

British Library Cataloguing in Publication Data.
A catalogue record for this book is available from the British Library.

Typesetting by SJmagic DESIGN SERVICES, India.
Printed in the UK.

ABOUT THE PHOTOGRAPHER

Matthew Pinner was born and raised for the early part of his life in the city of Southampton, Hampshire. After deciding at the age of twenty-two that he wanted to take up photography, he purchased his first camera after being left a tripod by his grandfather. It was his mission to learn everything he could by himself.

Matt's gallery of work is constantly expanding along with the requests for a book of his work. The inspiration behind this book is to showcase the pure beauty of the county of Dorset, which has been a massive part of his childhood, along with the amazing support of his mass social media following which reaches over 400,000 followers.

Matt's eight-year photography career has seen him achieve so much in such a short time. Many major TV outlets, newspapers and magazines have regularly asked to use his spectacular images nationally, to best represent the UK landscapes.

Matt uses a Canon 5D Mark IV with a range of lenses by Canon and he uses a wide range of filters by Lee Filters.

Website: http://pinners-photography.co.uk
Facebook: Pinner's Photography
Twitter: @Matt_Pinner
Instagram: @Matt_Pinner
Email: enquiriespinnersphotogrpahy@gmail.co.uk

ACKNOWLEDGEMENTS

I would like to start by saying that I am entirely grateful to so many of the people who are close to me for supporting me whist creating this book. First and most important is my beautiful wife, Emma, and our daughters Imogen and Sienna. You three have been my rock through this process and I love you very much.

There are also many members within the industry who have supported and guided me that I would like to do a special mention. Canon UK & Ireland, Angela Nicholson from *Camera Jabber*, Dean Murray from *Cover Images*, the people from *Bournemouth Echo*, Holly Green from *ITV weather*, Elliot Wagland, John Challis, *Dorset Magazine*, Paul Vass, Gareth Richman and Elie Gordon from *BBC Earth*.

INTRODUCTION

I first became interested in photography after my grandfather sadly passed away, leaving his tripod in his will for me. I found the inspiration from there and have never looked back. I live by the saying 'you miss every shot you don't take'. With every chance I get I'm constantly researching the next place to capture with my camera, and when I'm free to explore I'm gone roaming around the UK's southern coast to capture as many images as I possibly can.

 All the images within this book have been collected mainly over the last year; with taking these images I have been exploring as much as the county of Dorset as I possibly could, and within that I have chosen the ones that mean something to myself. The images are a continuation from my last book, *Dorset in Photographs*, that show other aspects of our gorgeous coastline.

 I love photography so much and I enjoy sharing the magical views I see in the early hours and last minutes of the day. I hope you enjoy the book as much as I enjoyed creating it.

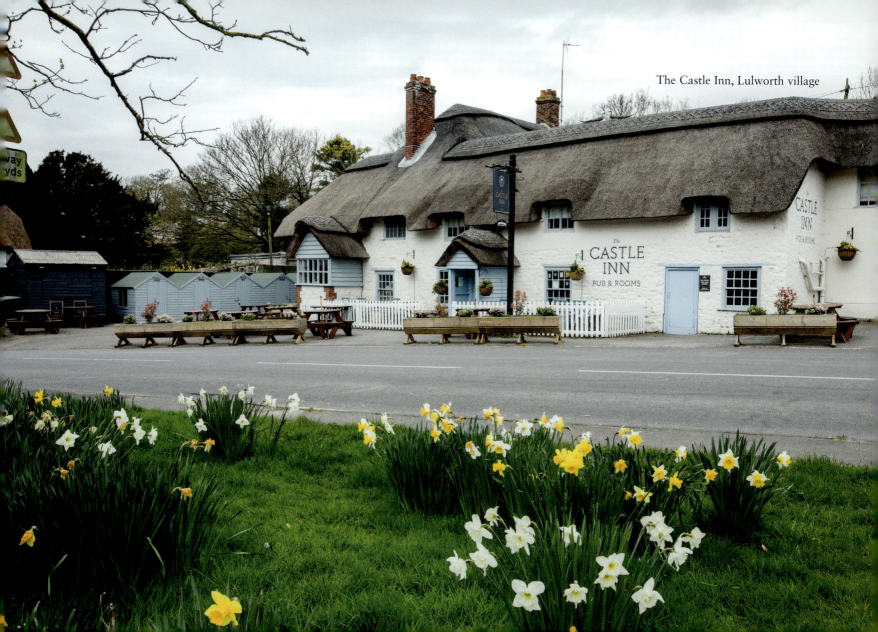

The Castle Inn, Lulworth village

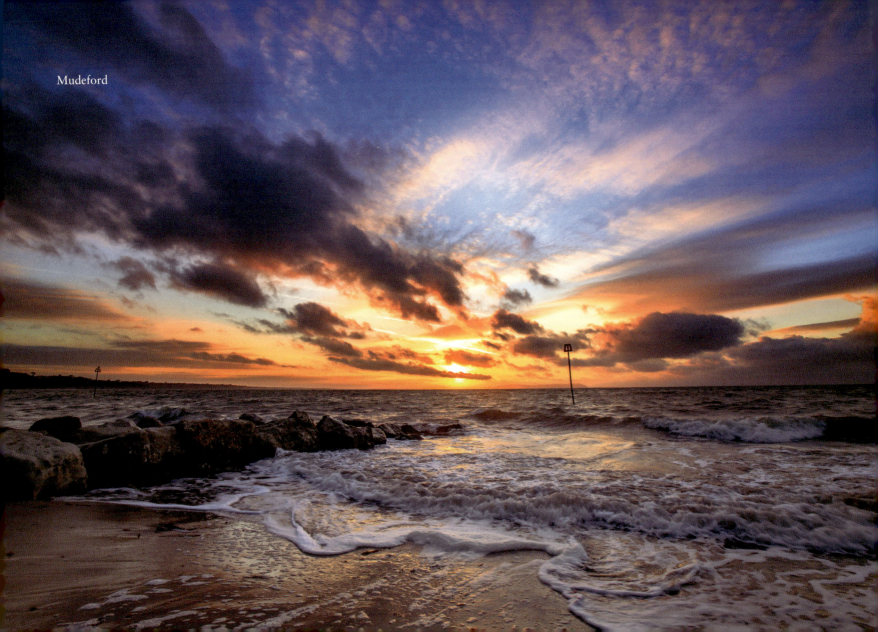

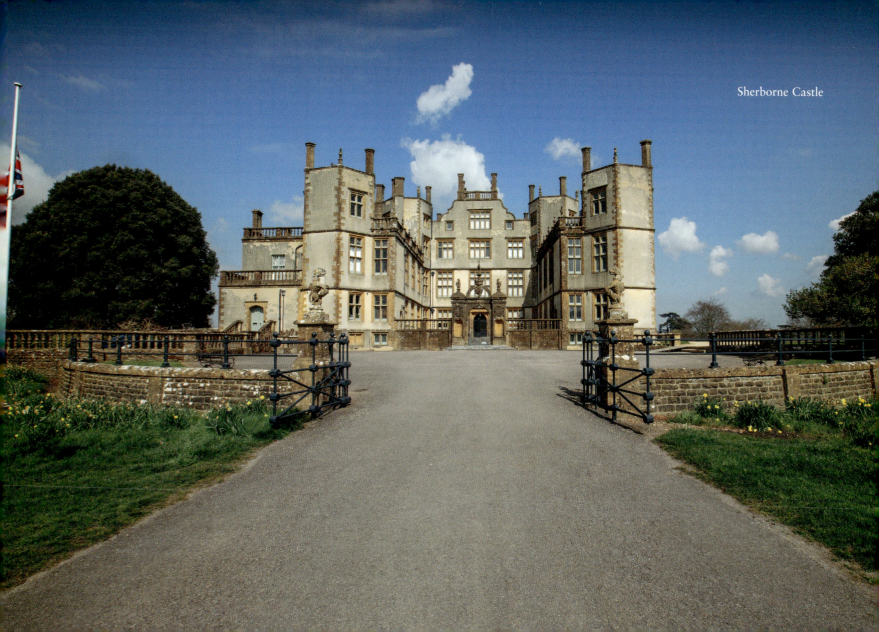
Sherborne Castle

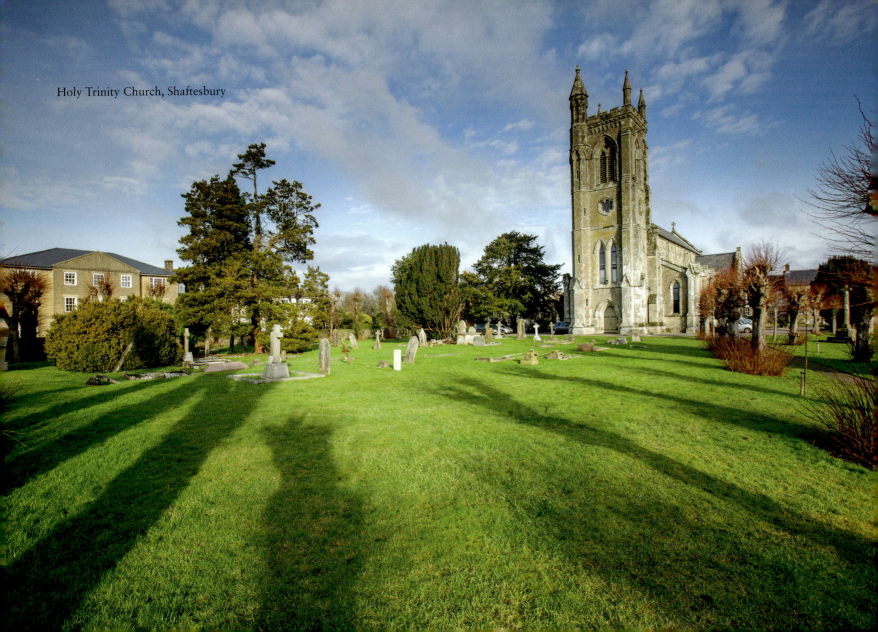
Holy Trinity Church, Shaftesbury

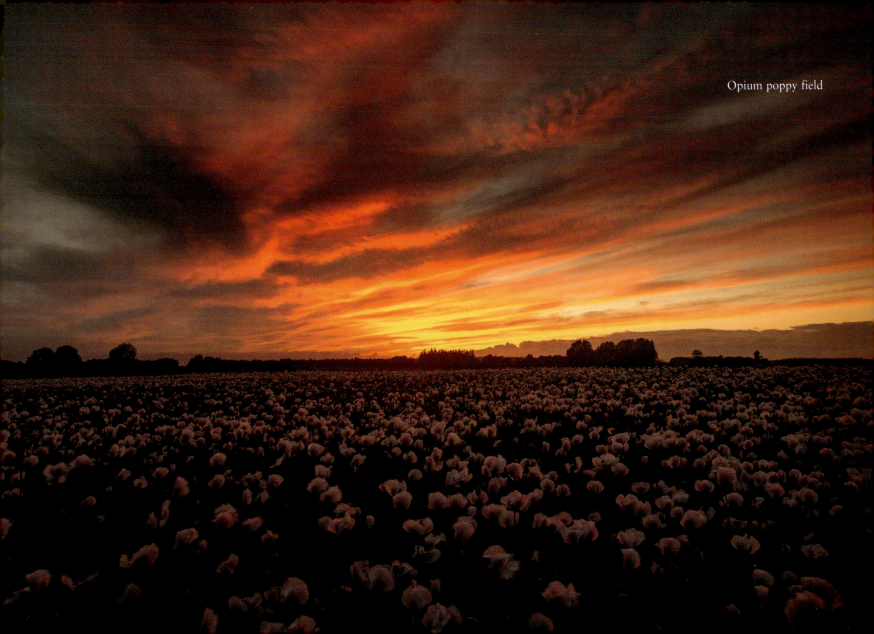

Opium poppy field

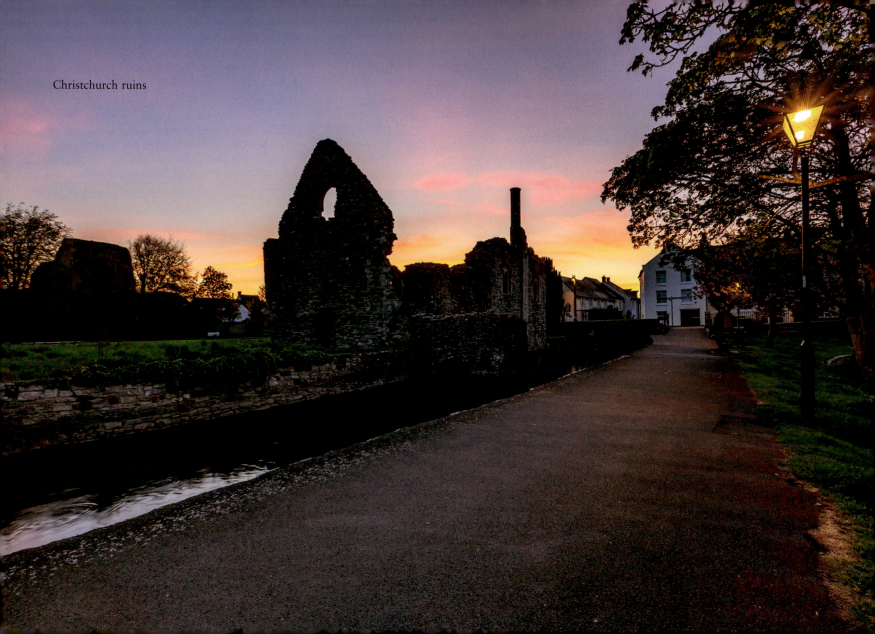
Christchurch ruins

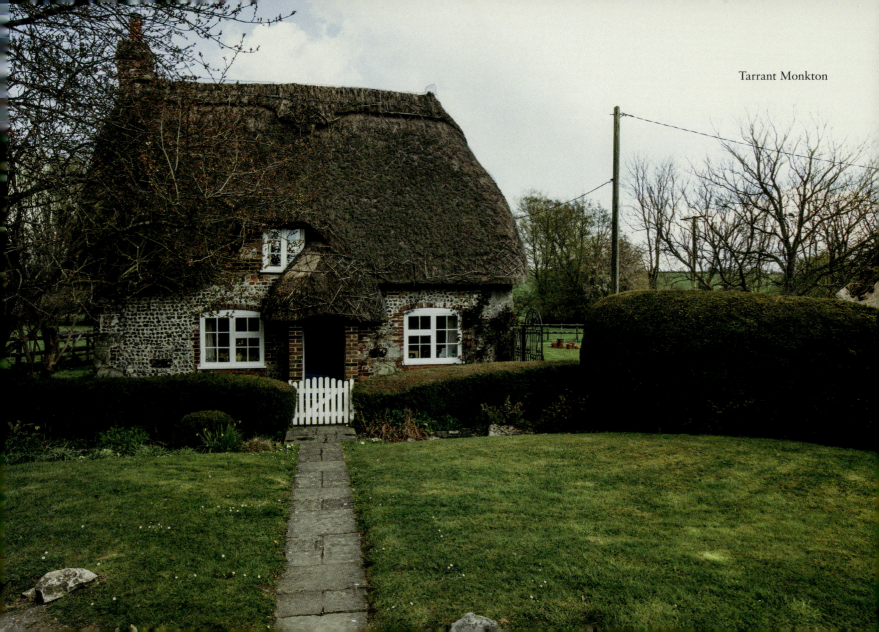
Tarrant Monkton

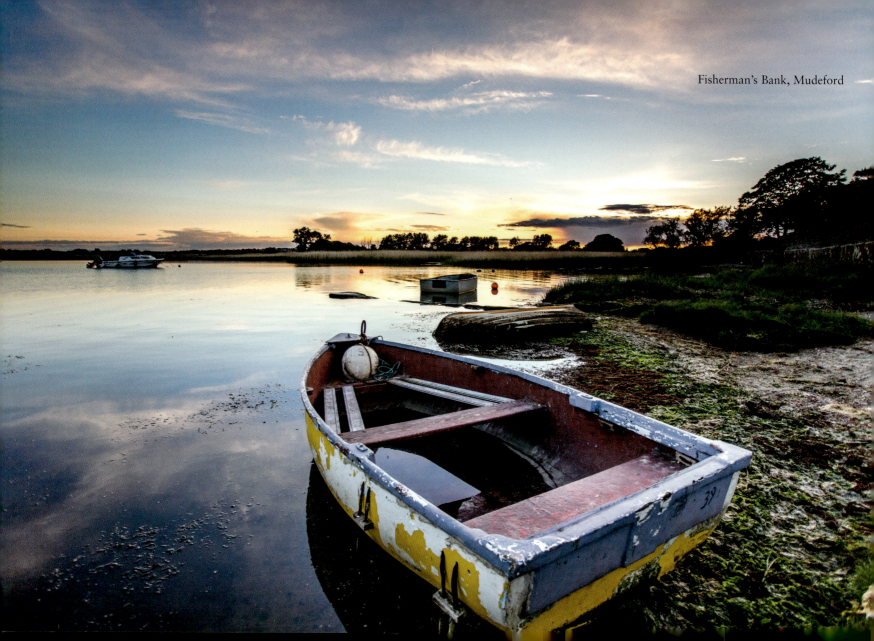

Fisherman's Bank, Mudeford

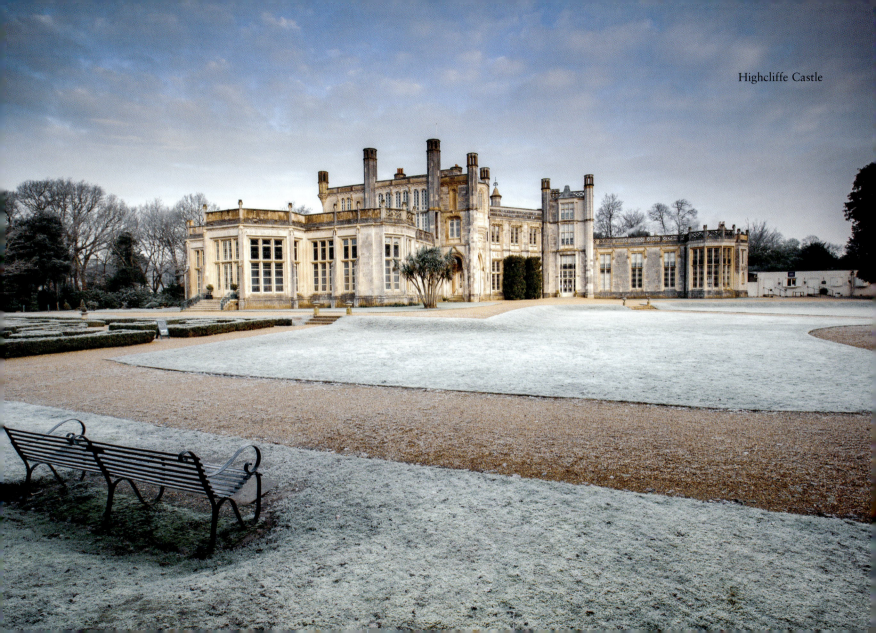
Highcliffe Castle

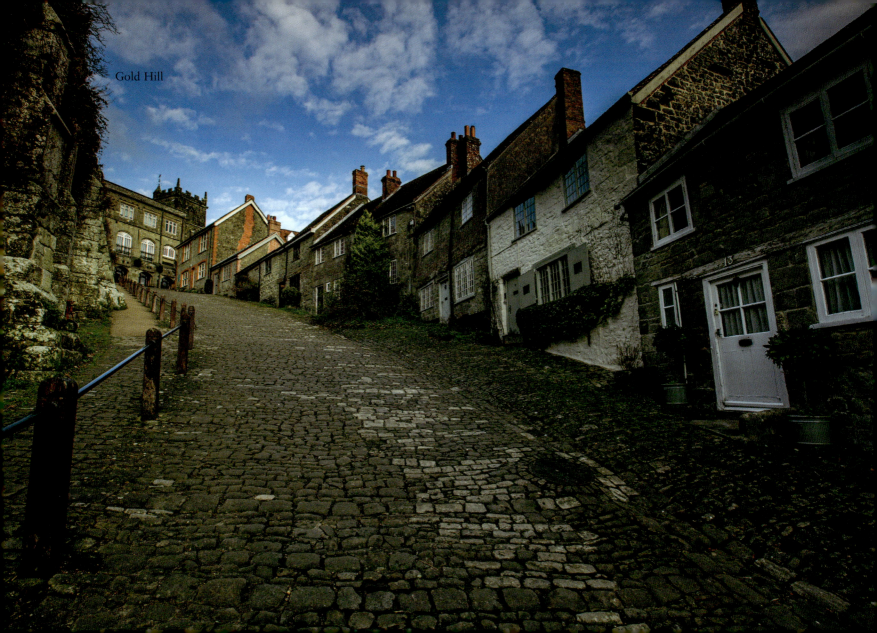
Gold Hill

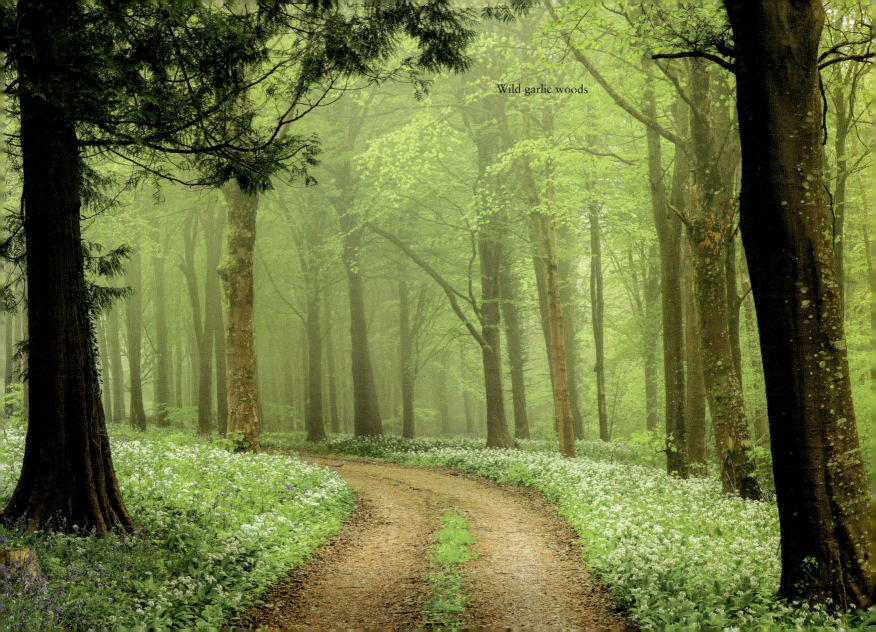
Wild garlic woods

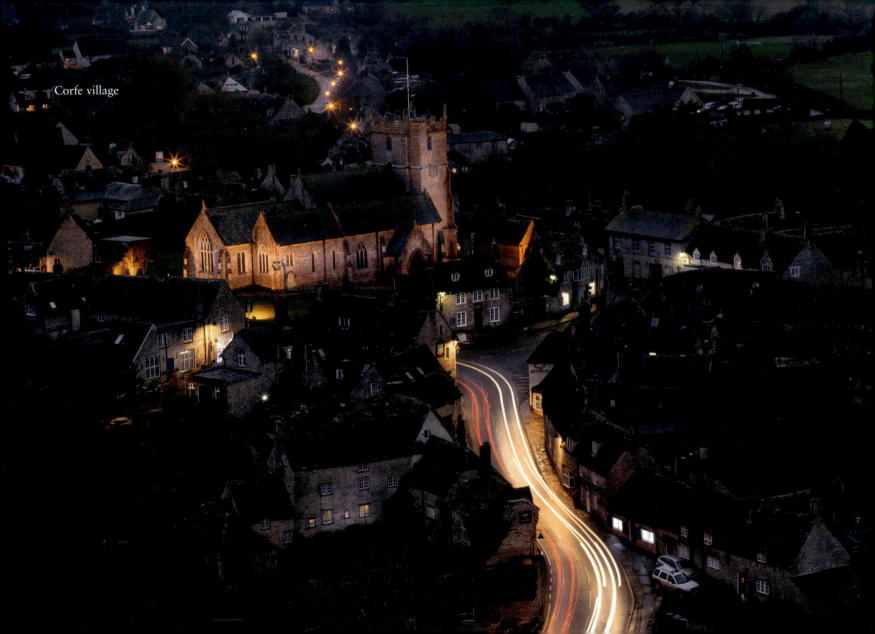
Corfe village

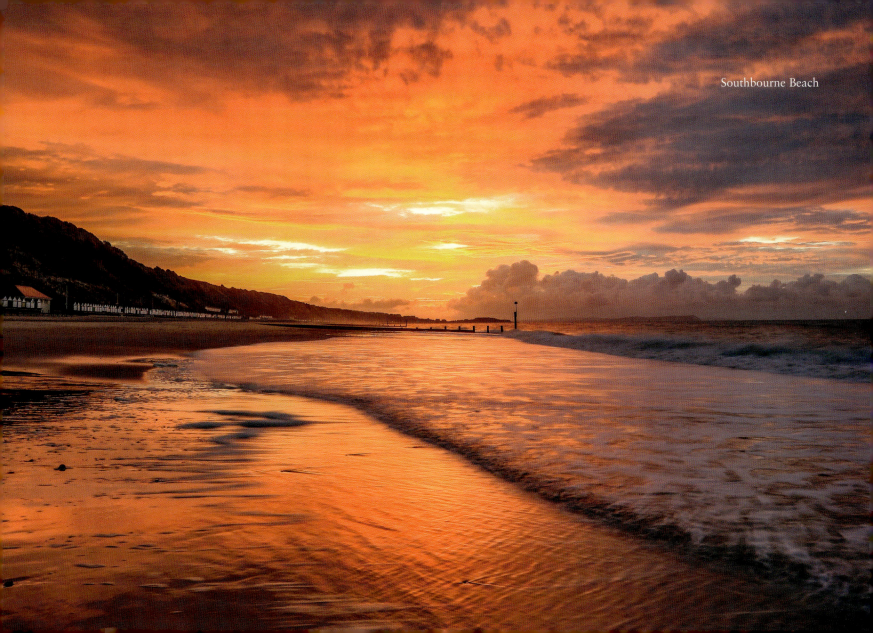

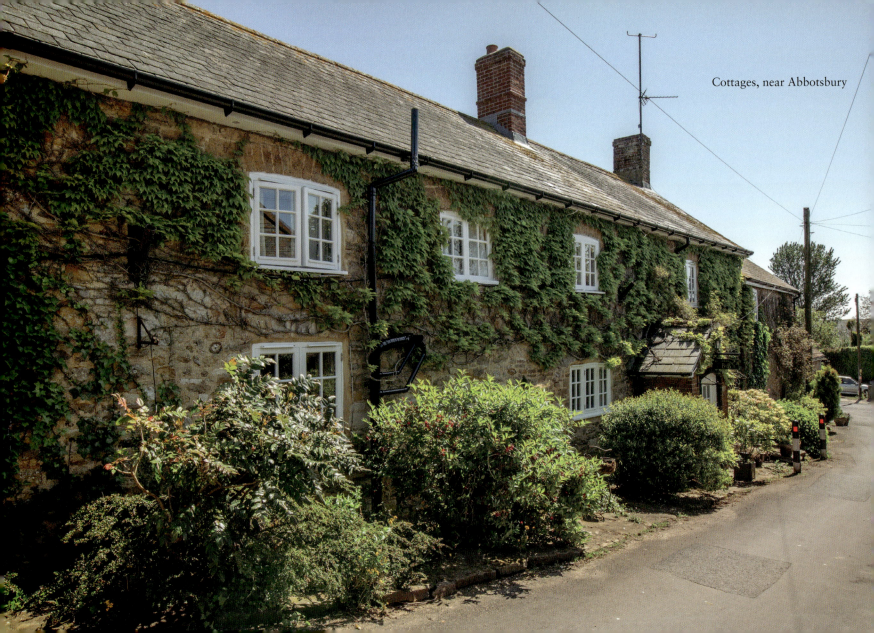
Cottages, near Abbotsbury

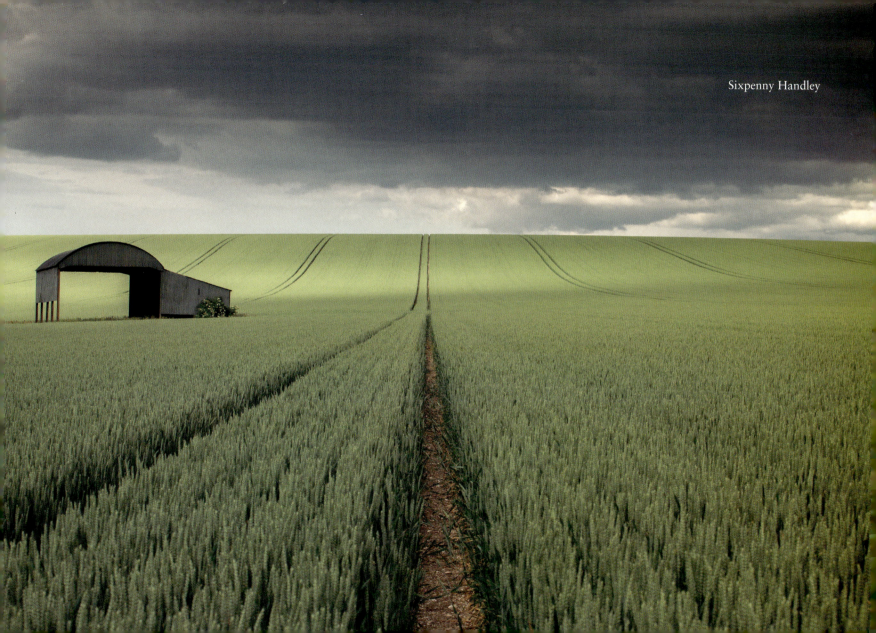
Sixpenny Handley

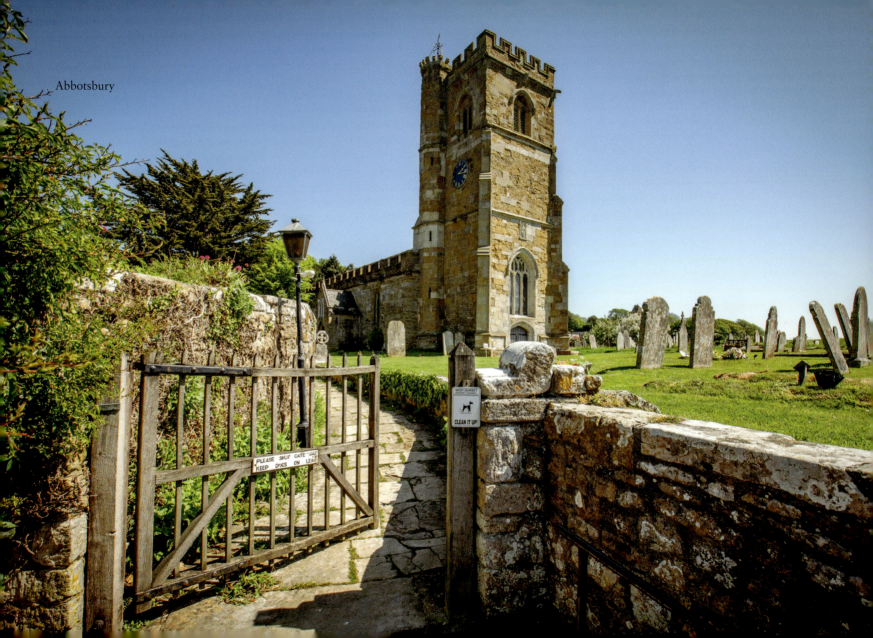
Abbotsbury

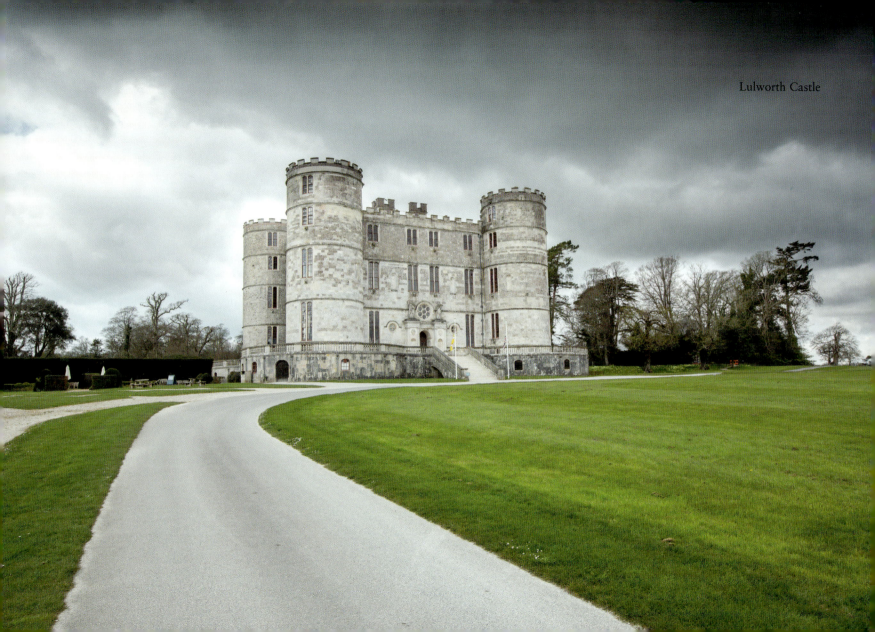
Lulworth Castle

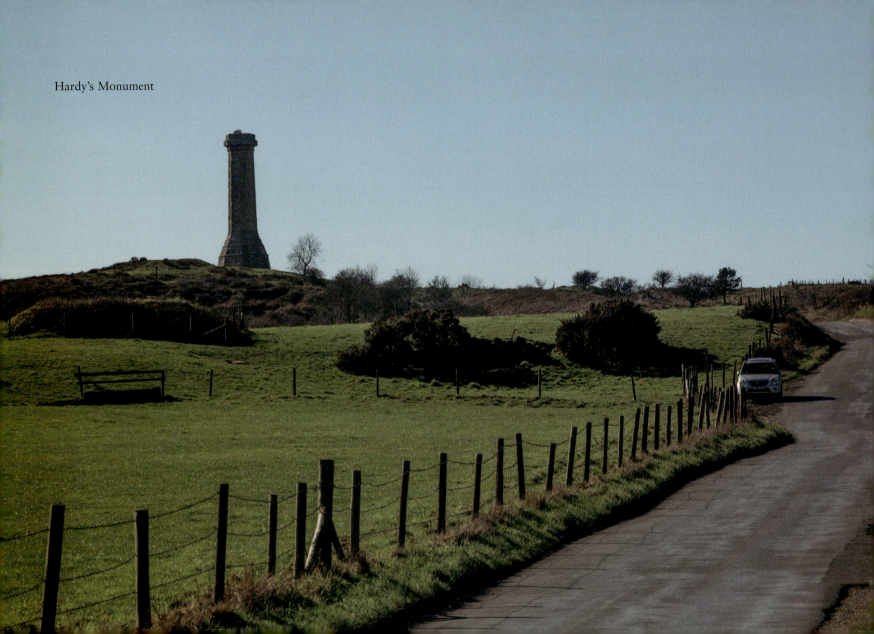
Hardy's Monument

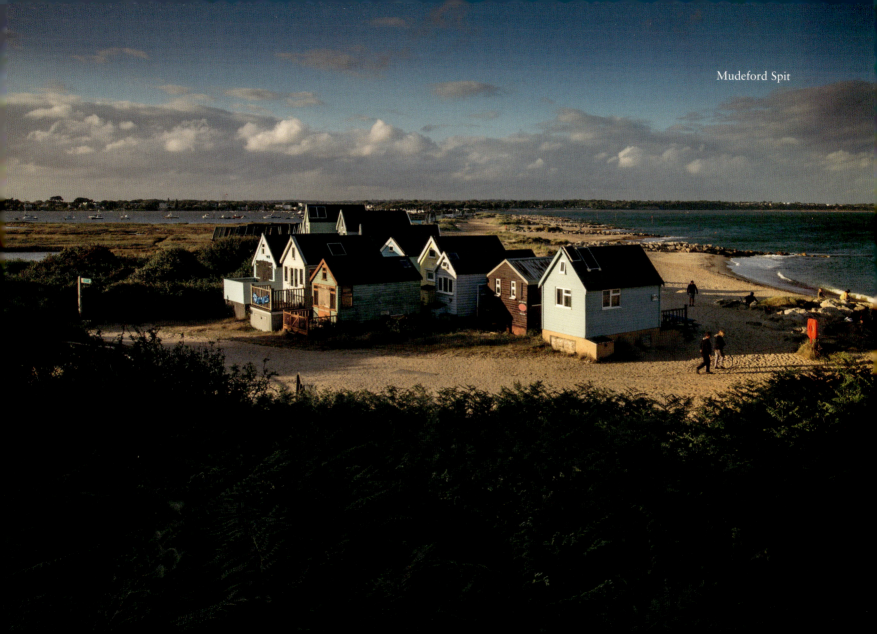

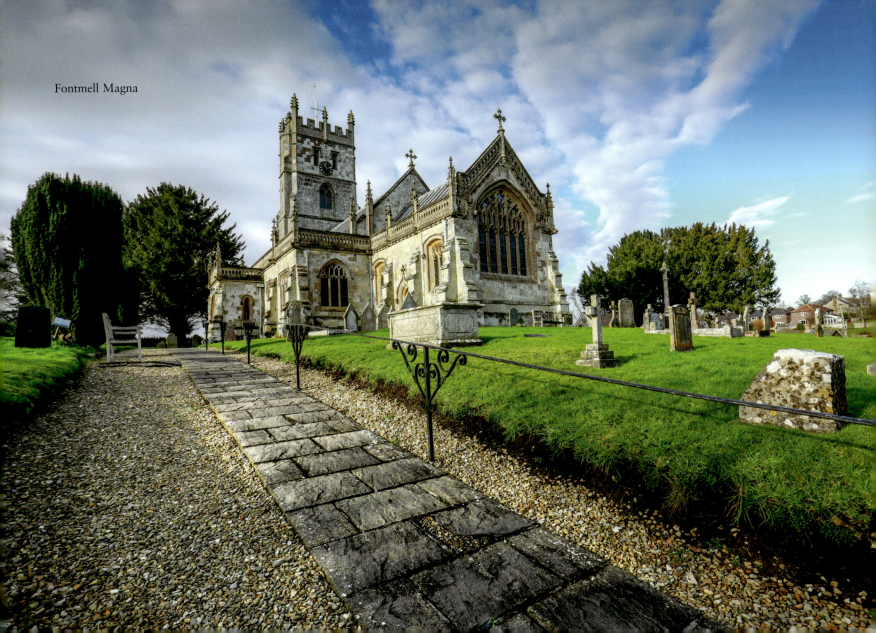

Fontmell Magna

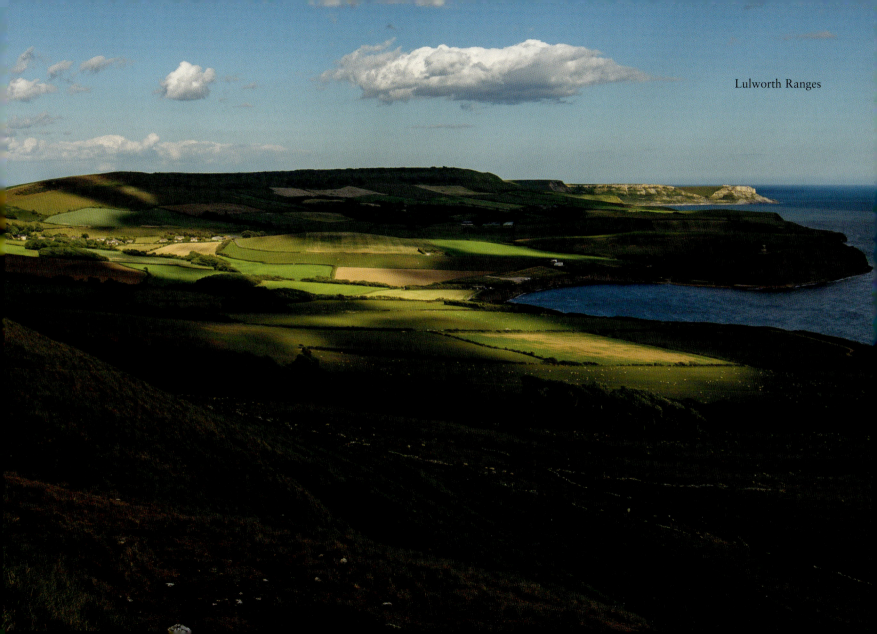
Lulworth Ranges

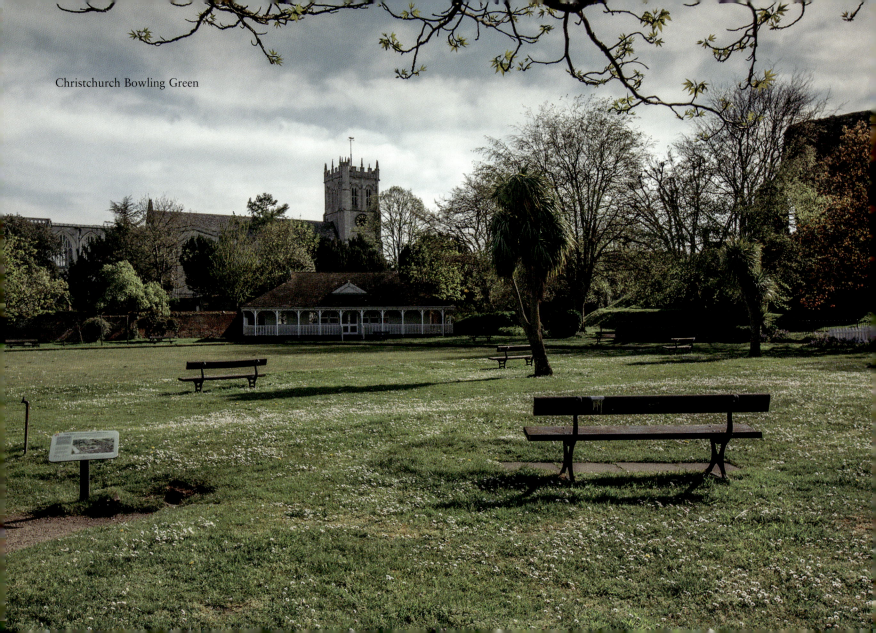
Christchurch Bowling Green

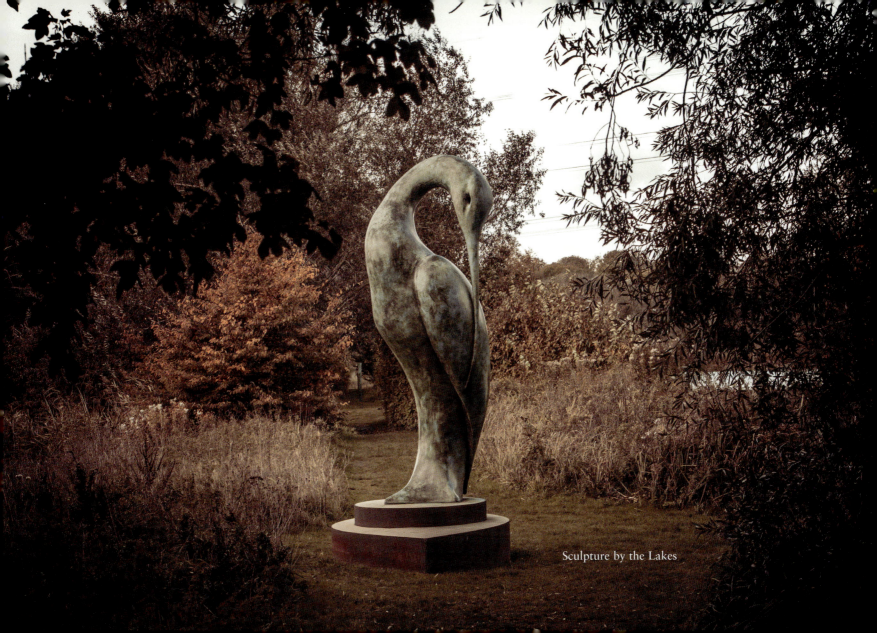
Sculpture by the Lakes

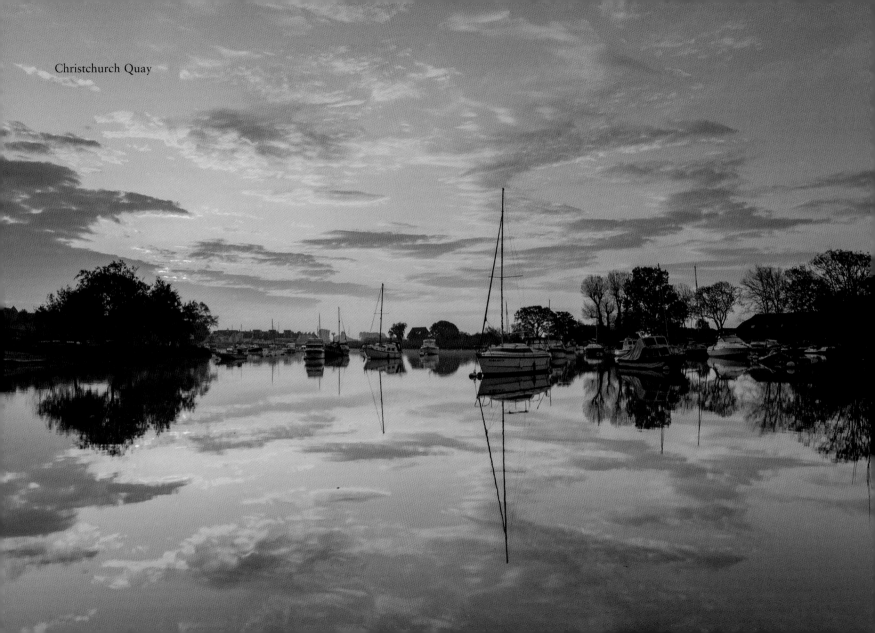

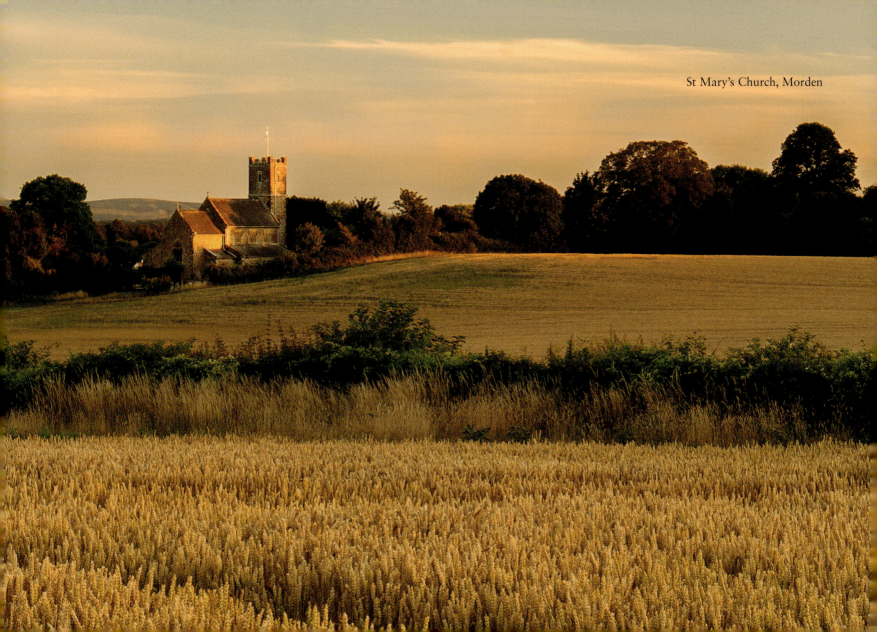
St Mary's Church, Morden

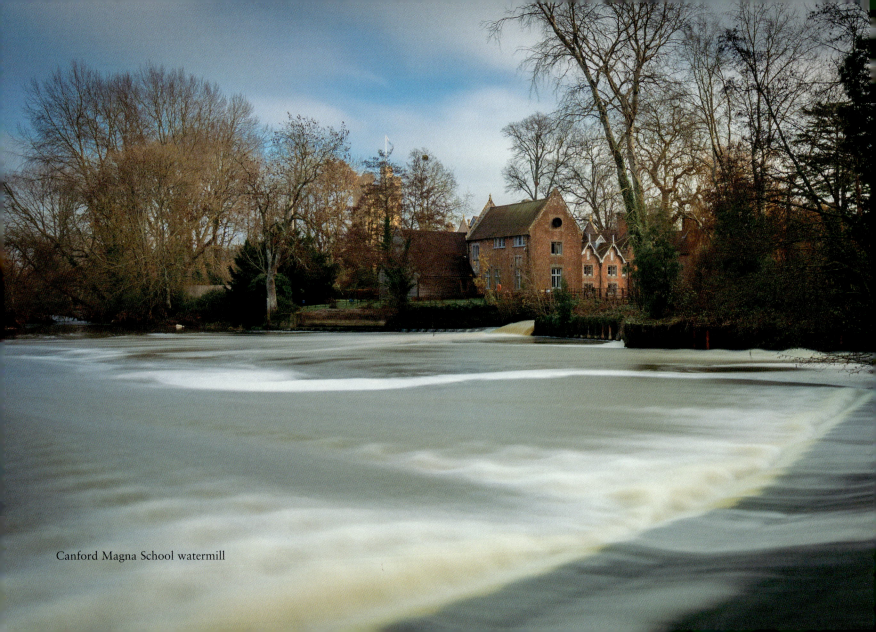
Canford Magna School watermill

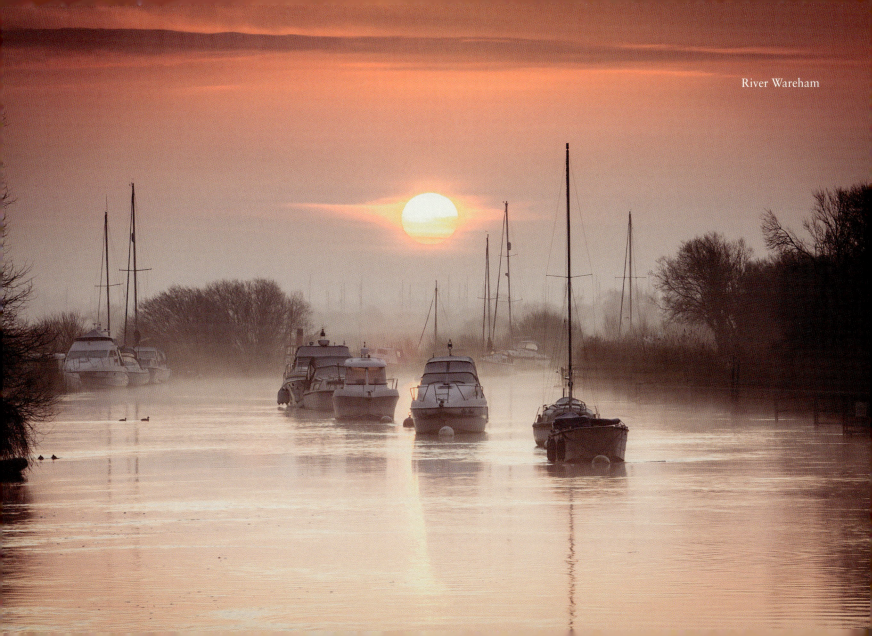
River Wareham

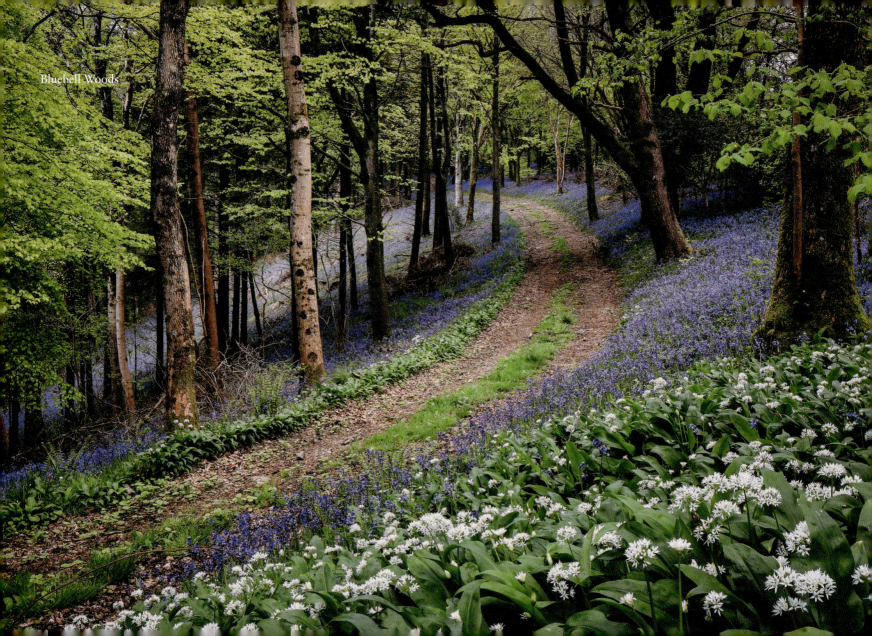
Bluebell Woods

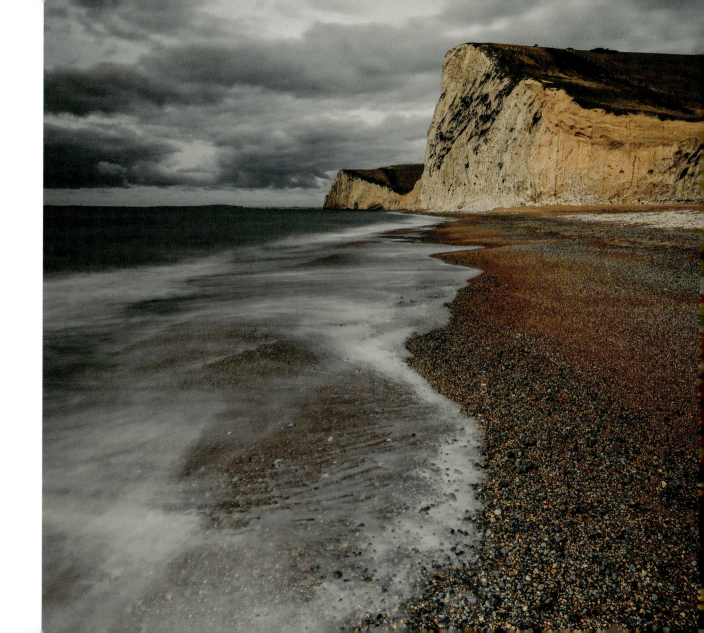

Bat's Head

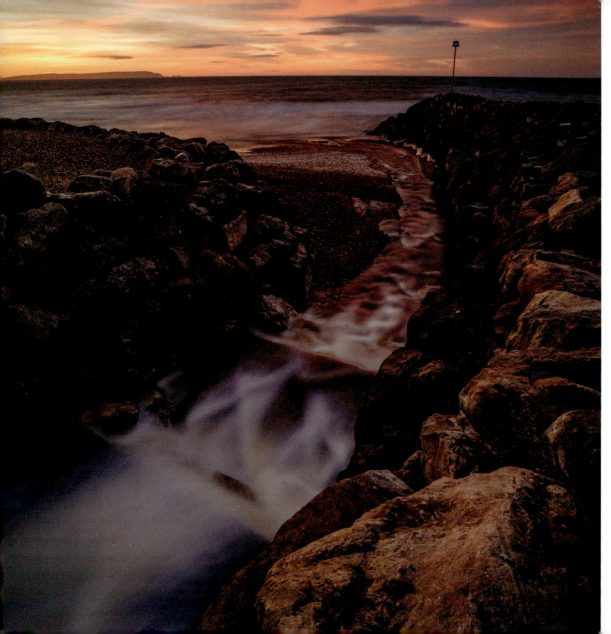

Highcliffe Beach

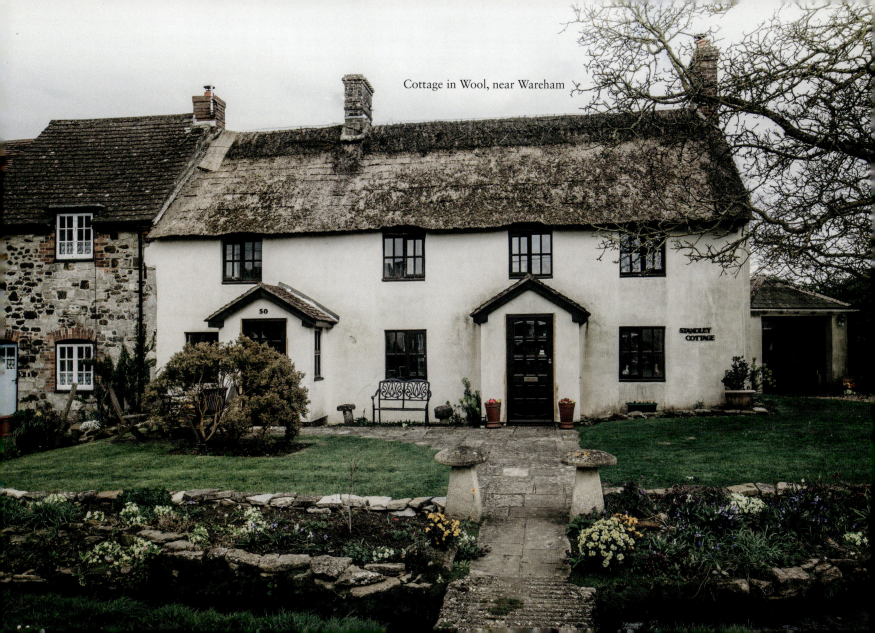
Cottage in Wool, near Wareham

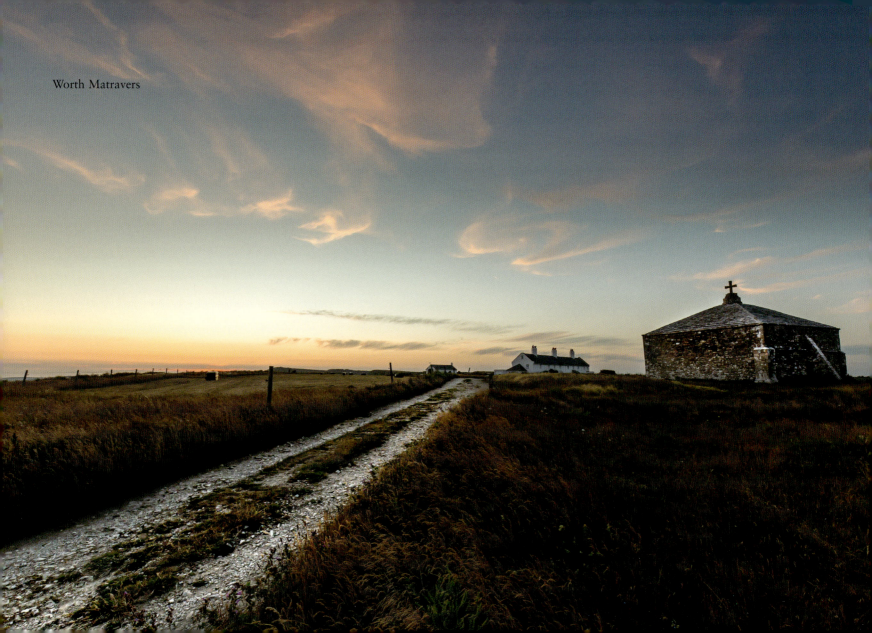
Worth Matravers

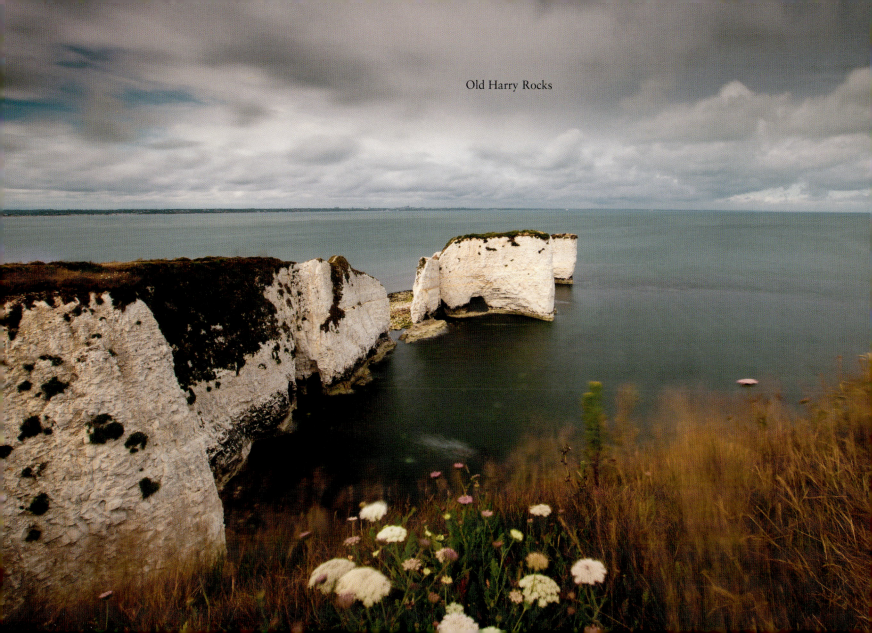
Old Harry Rocks

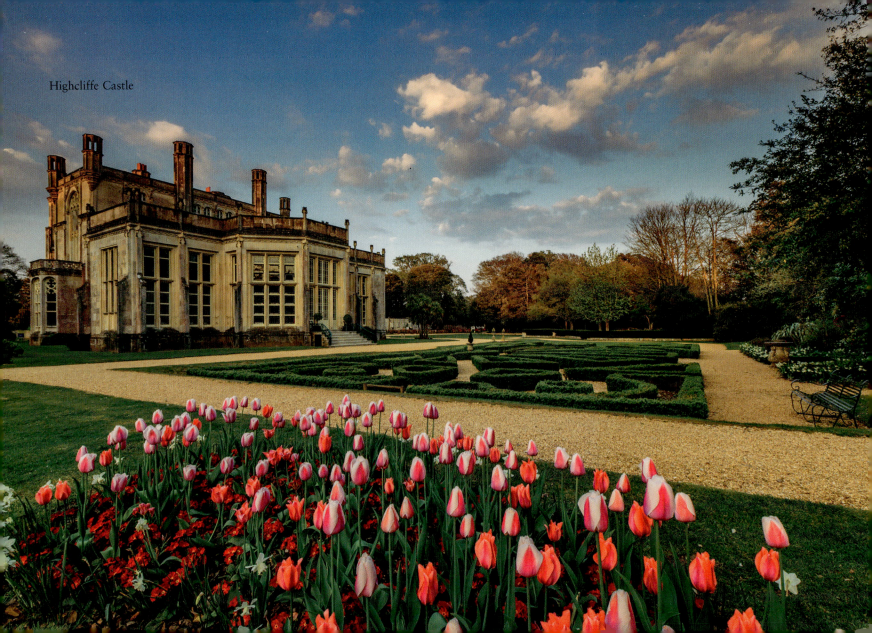
Highcliffe Castle

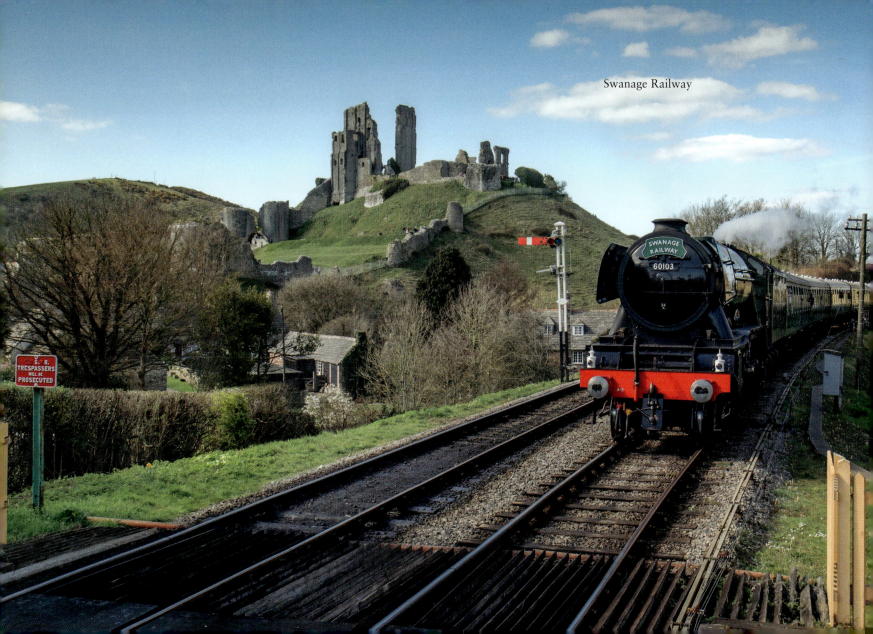

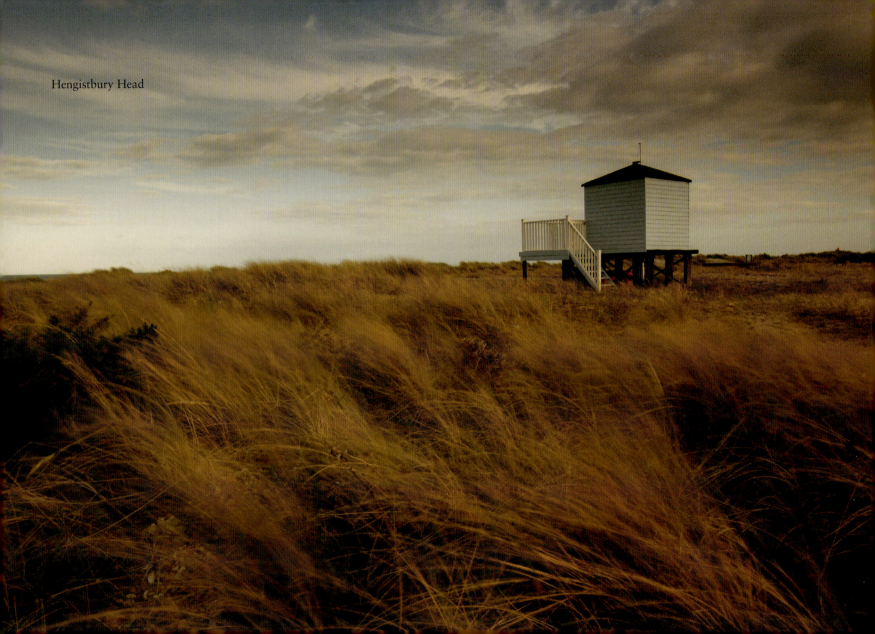
Hengistbury Head

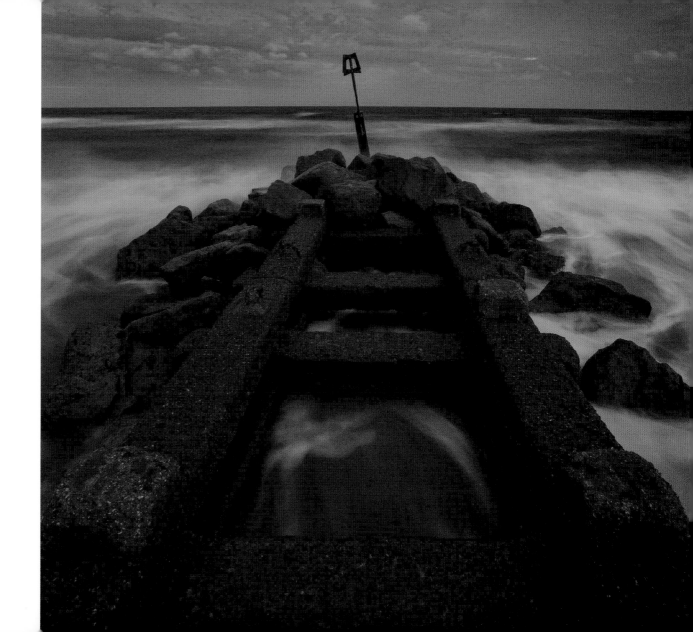

Southbourne

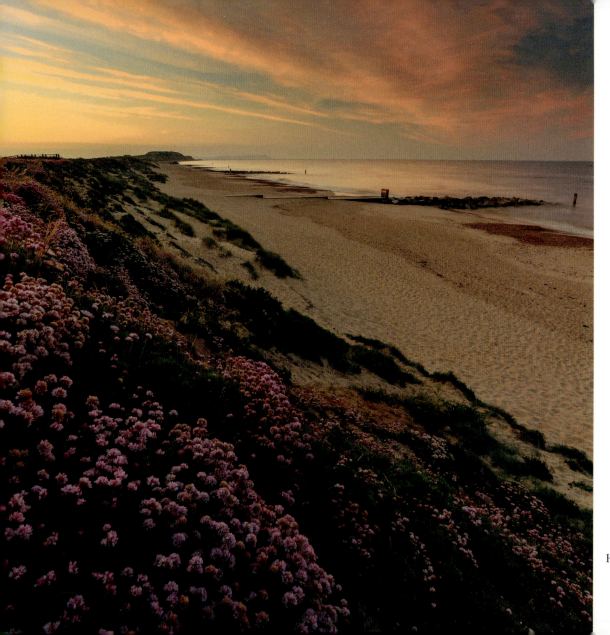

Hengistbury Head

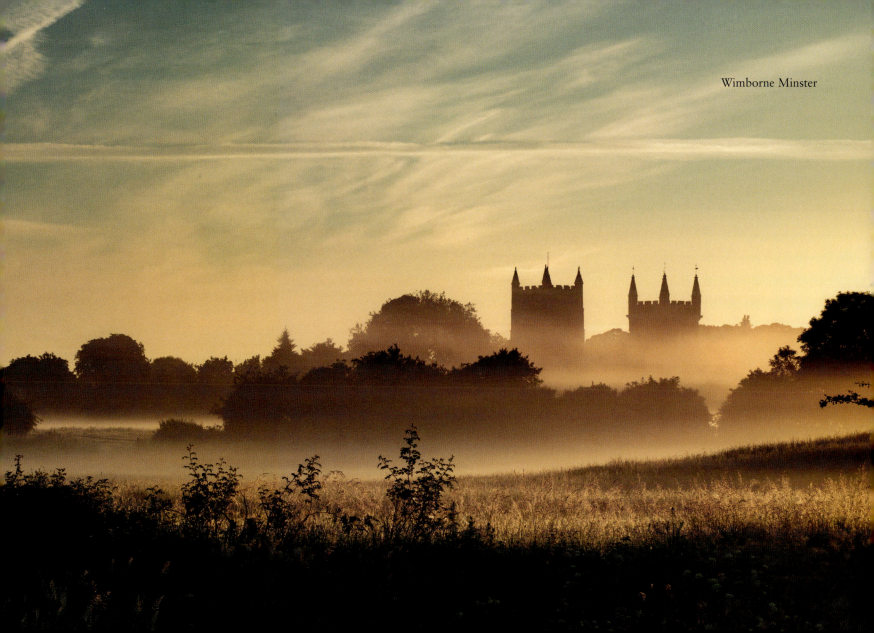
Wimborne Minster

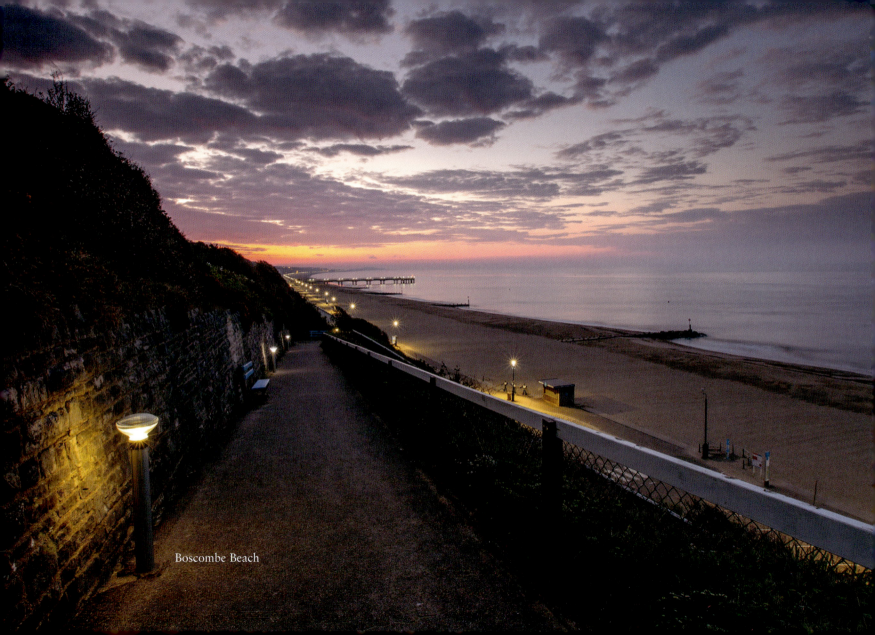
Boscombe Beach

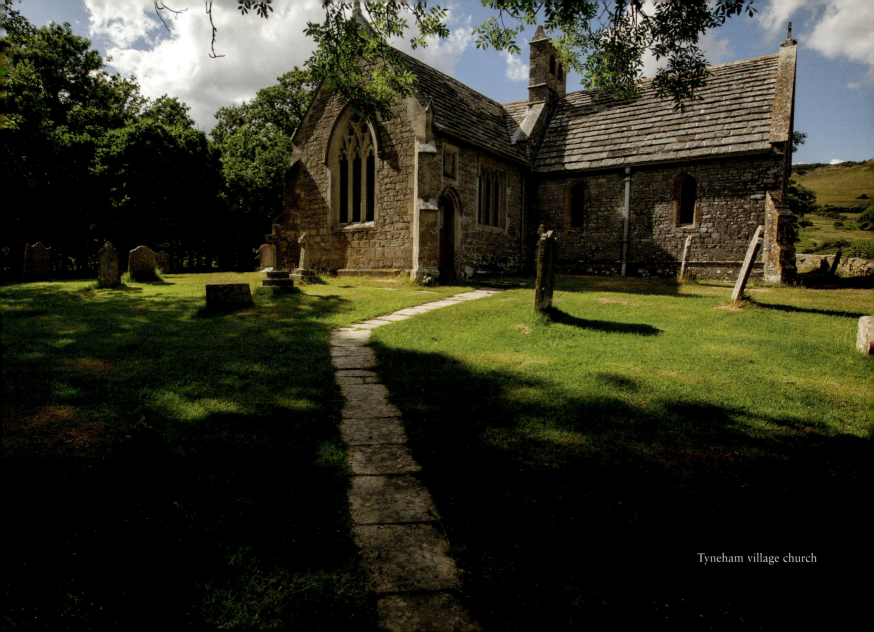
Tyneham village church

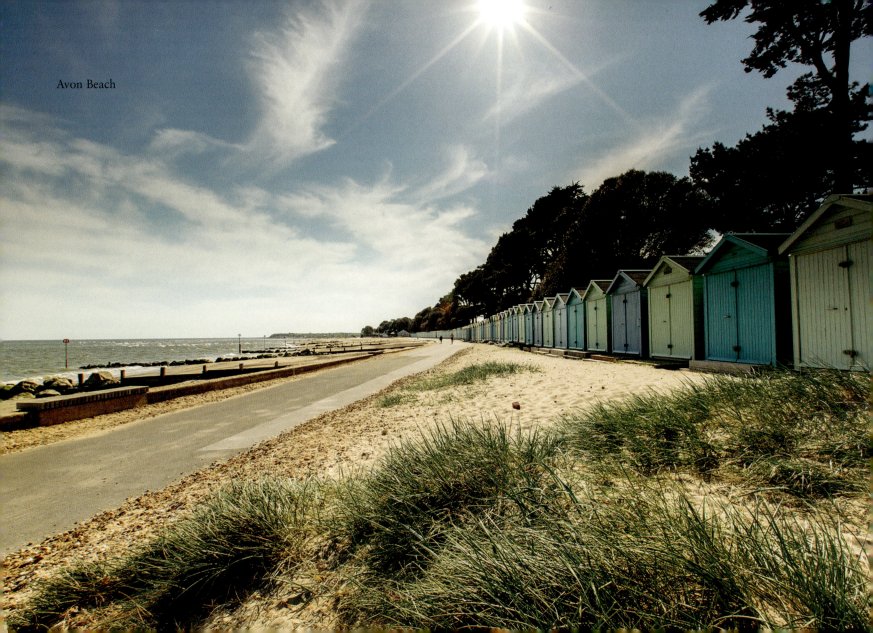
Avon Beach

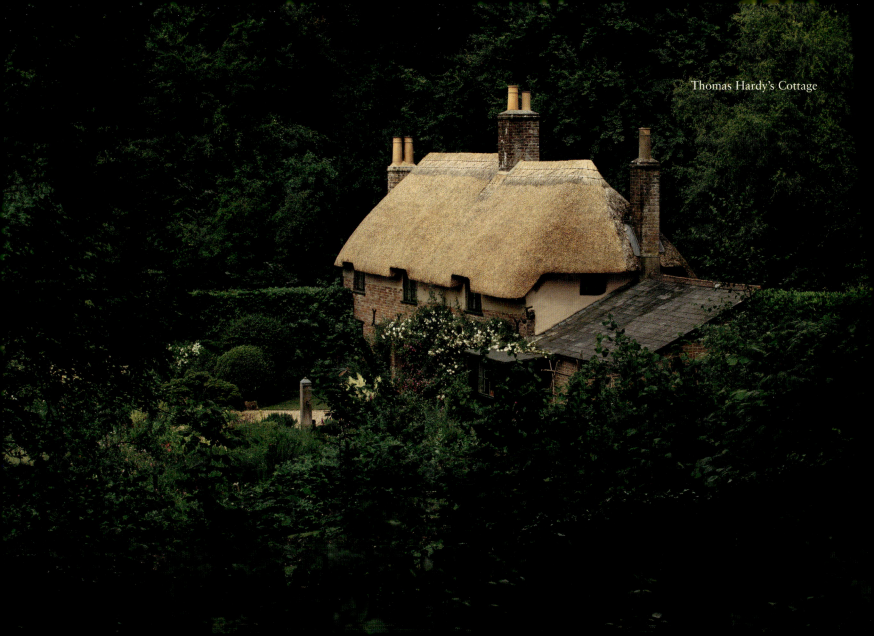
Thomas Hardy's Cottage

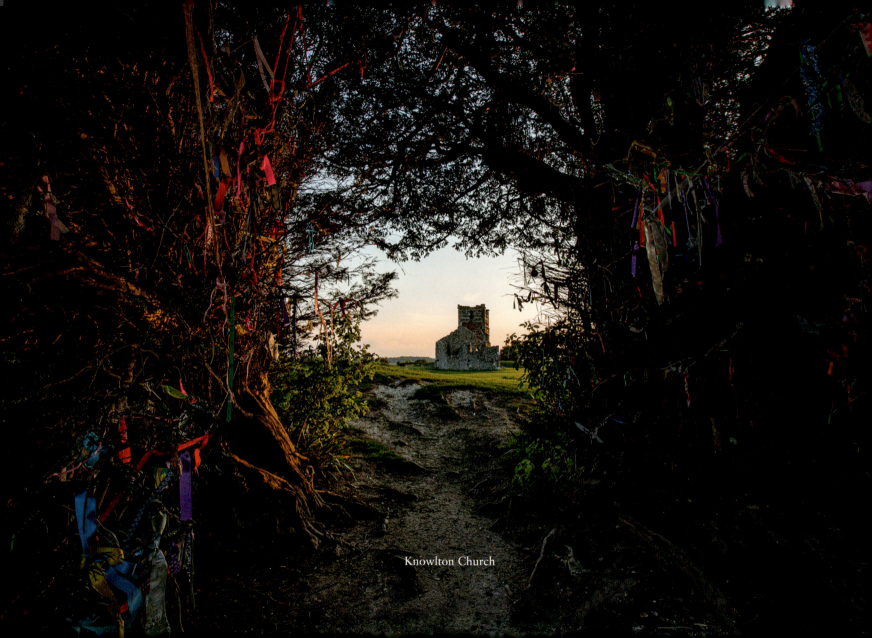
Knowlton Church

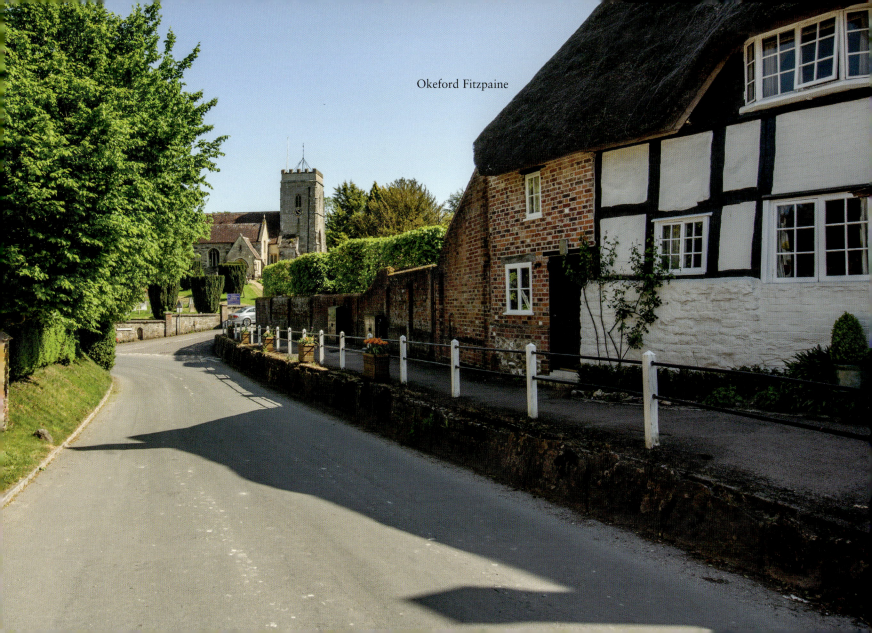
Okeford Fitzpaine

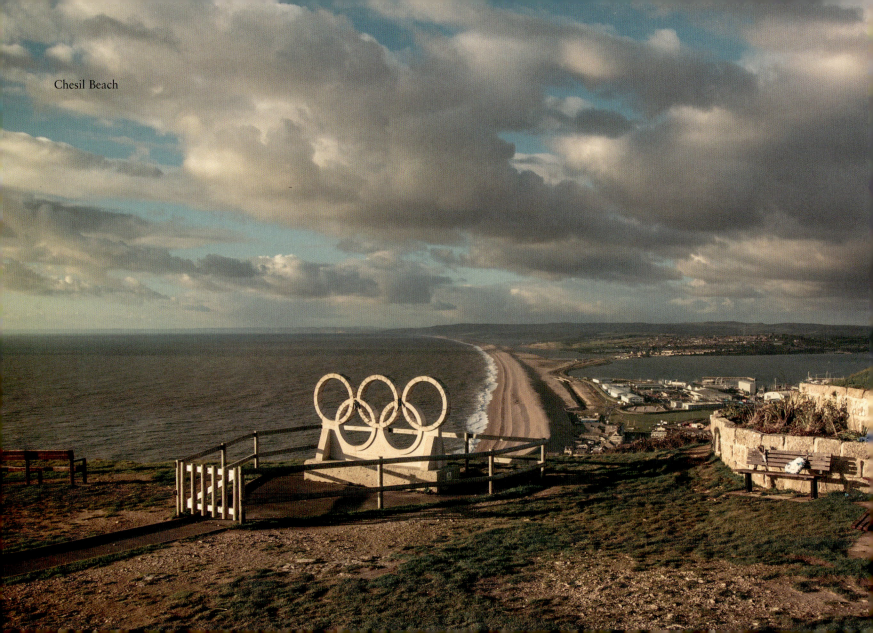
Chesil Beach

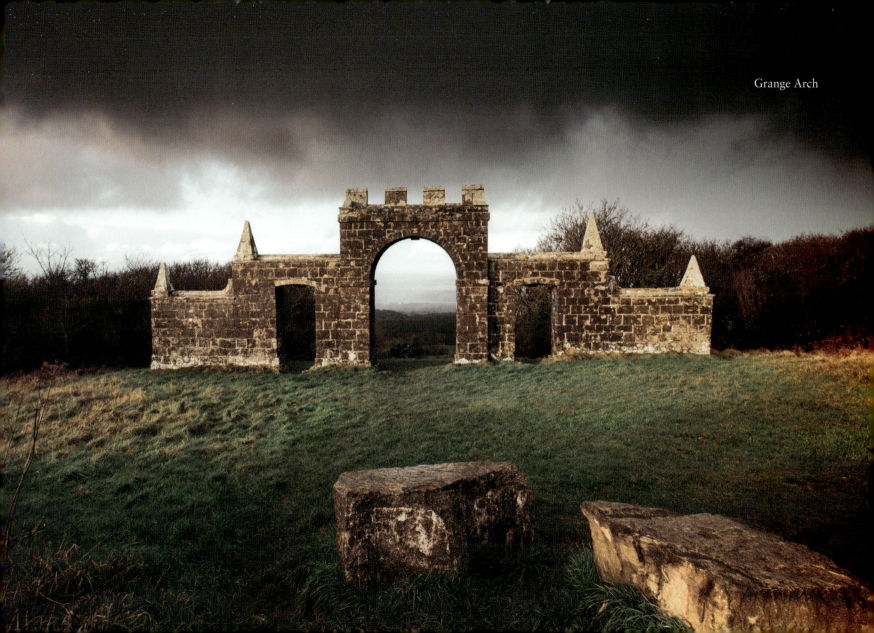
Grange Arch

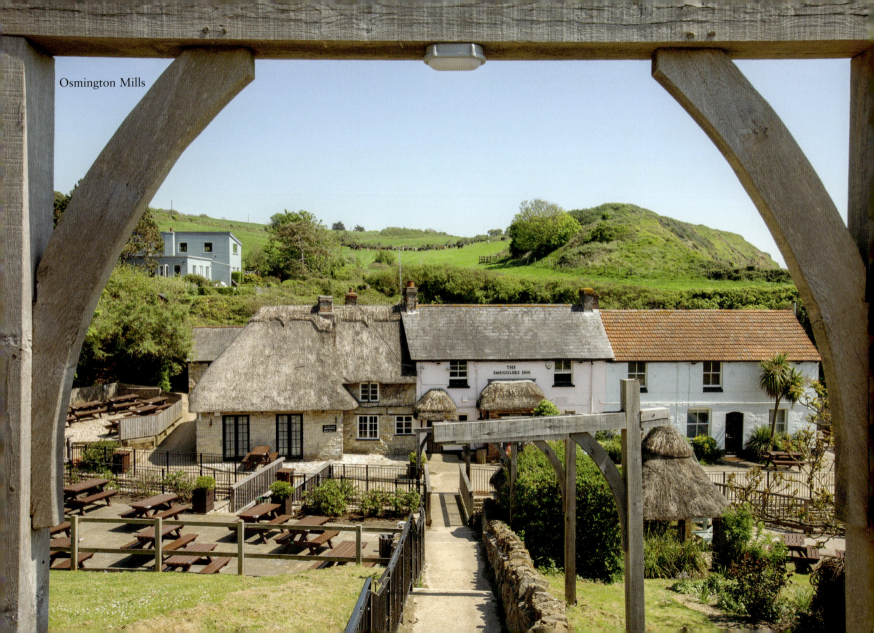
Osmington Mills

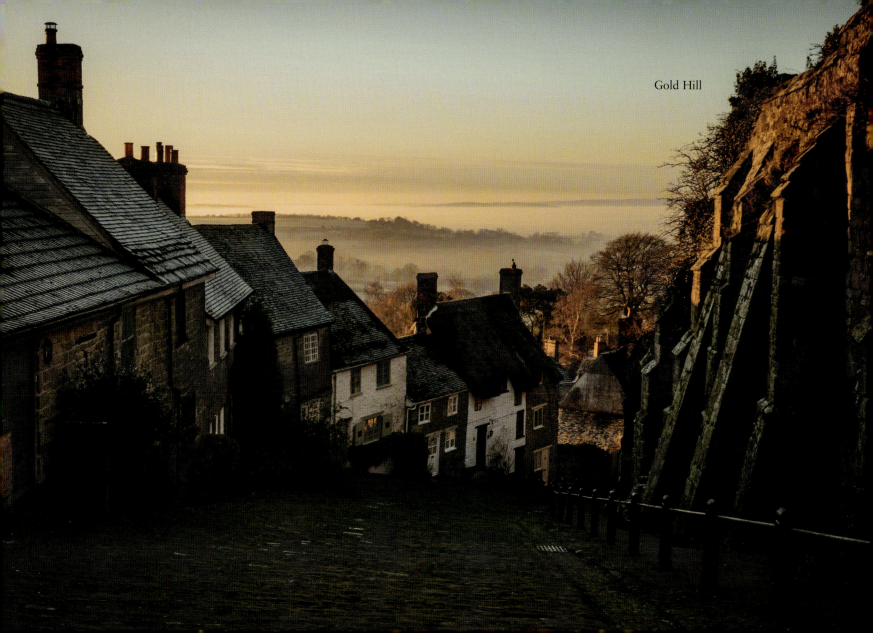
Gold Hill

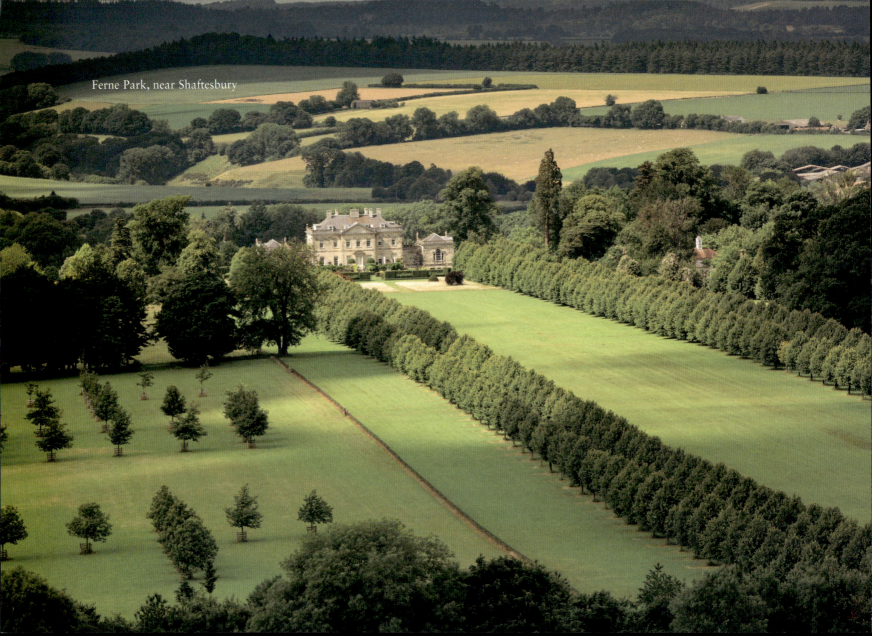
Ferne Park, near Shaftesbury

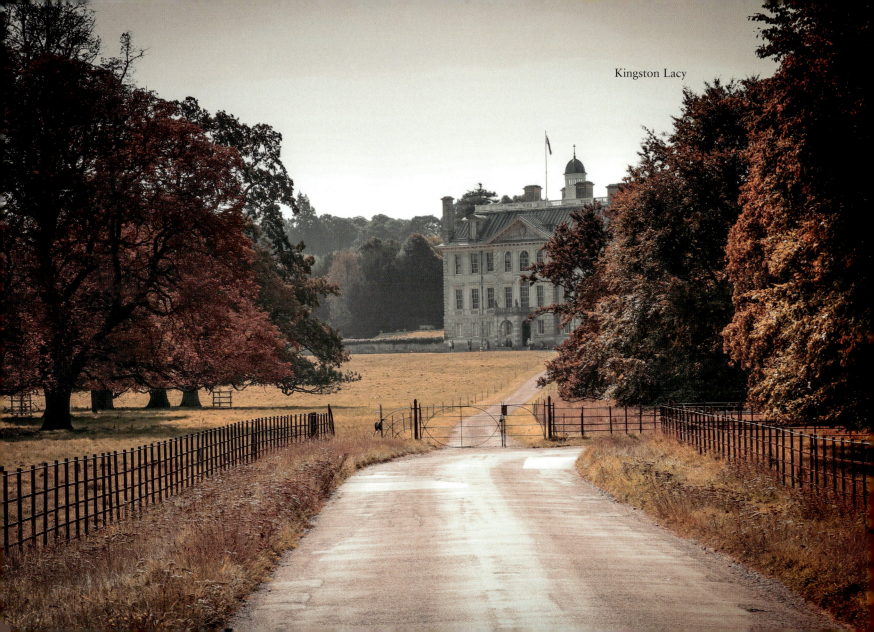

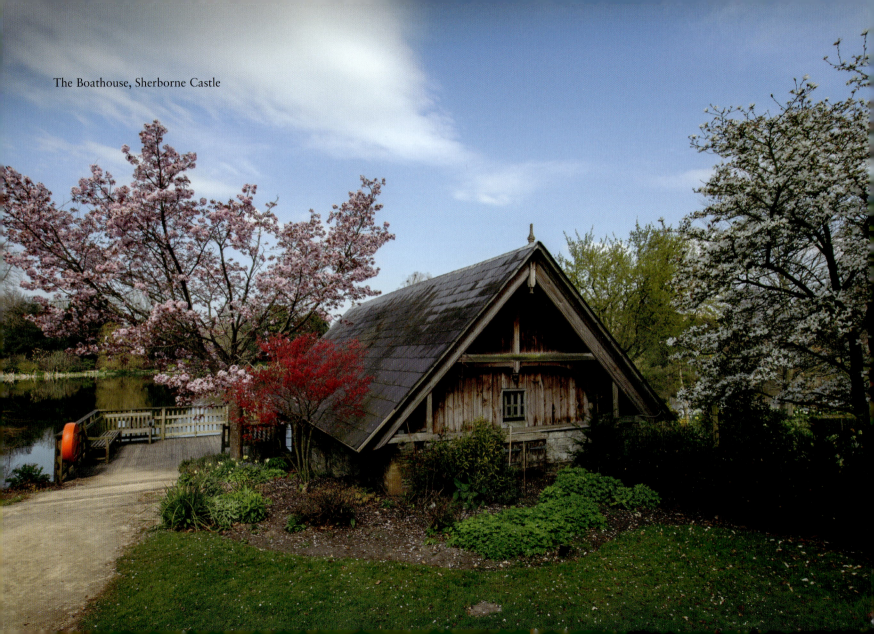
The Boathouse, Sherborne Castle

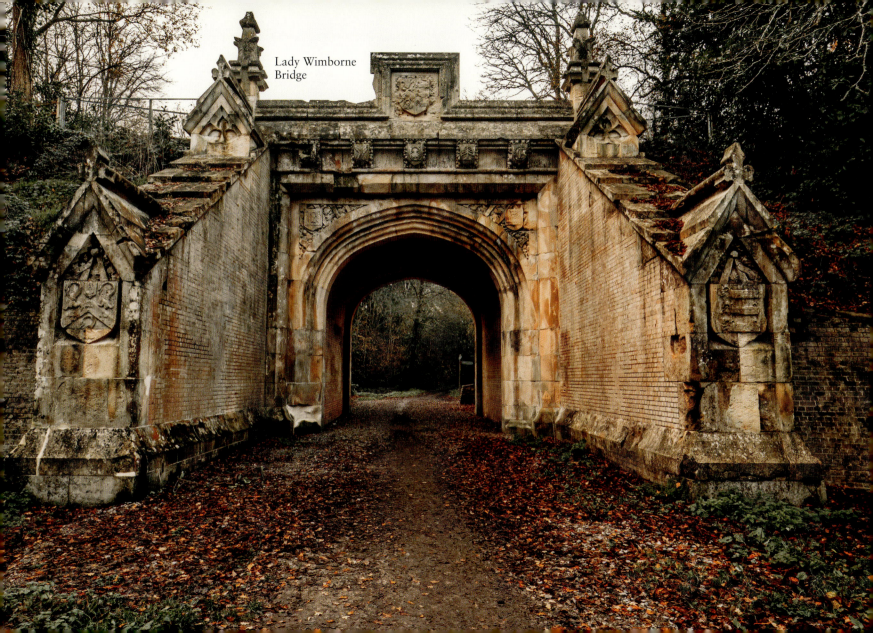
Lady Wimborne Bridge

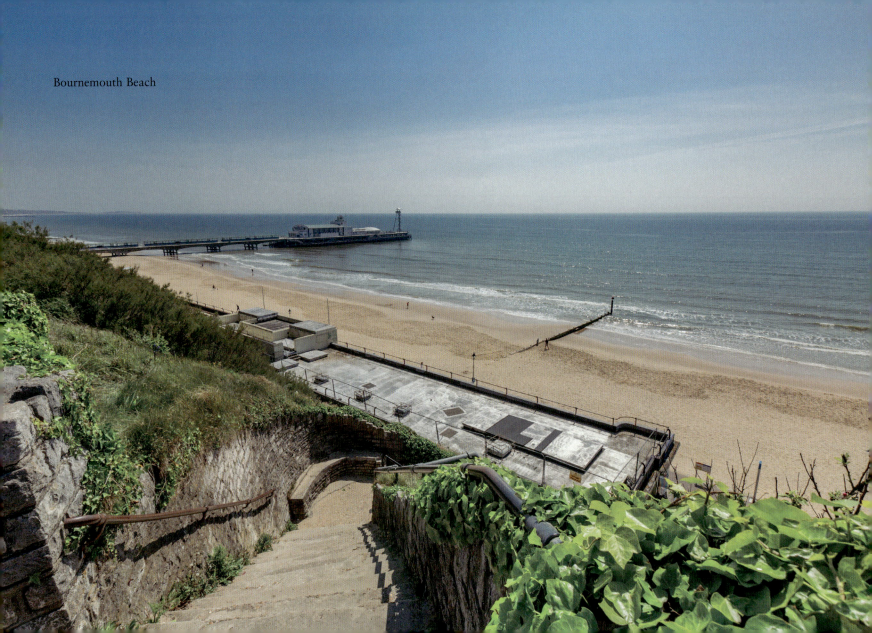
Bournemouth Beach

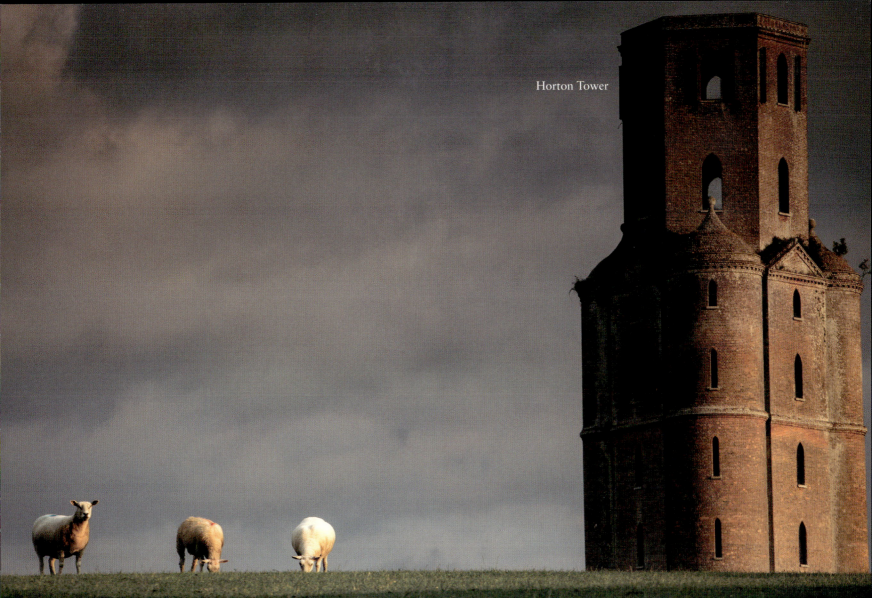
Horton Tower

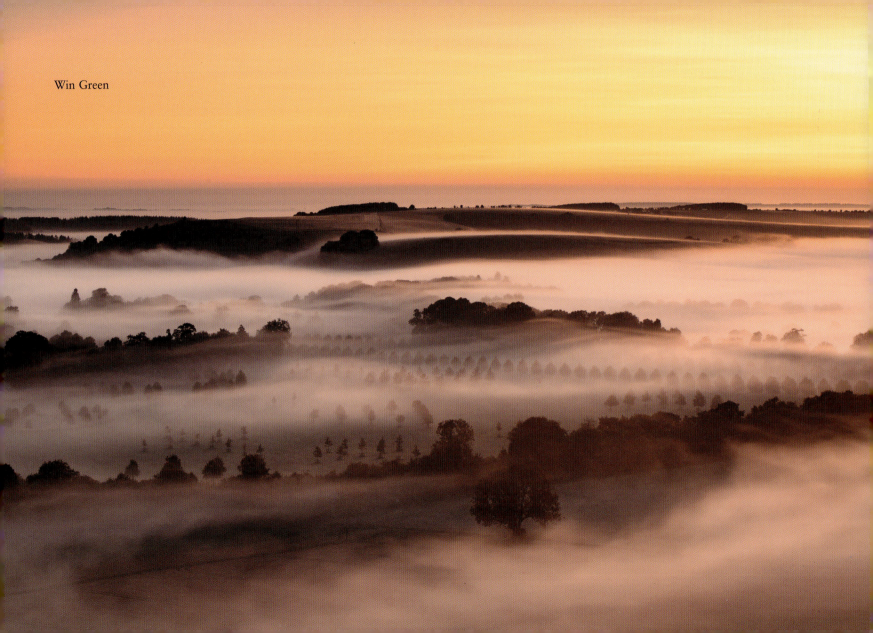
Win Green

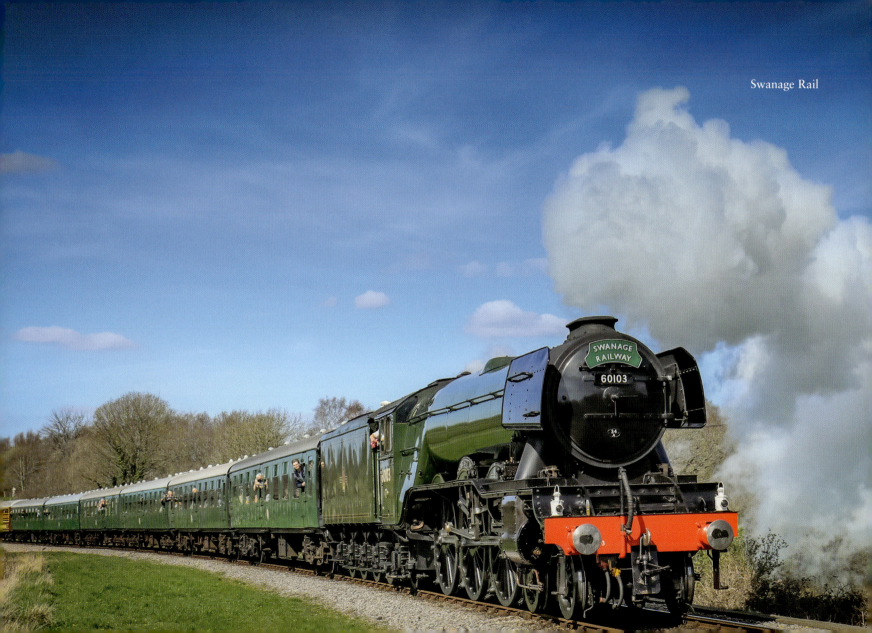
Swanage Rail

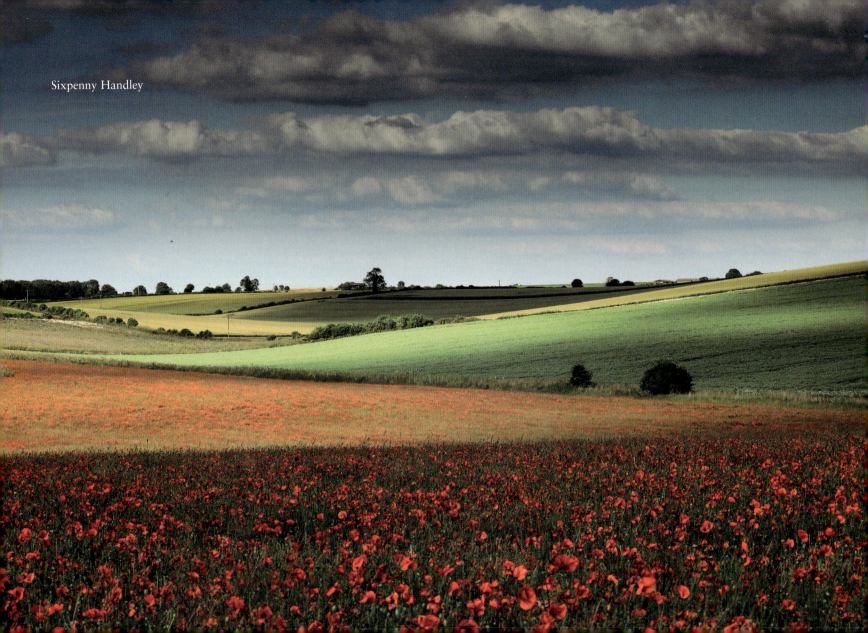
Sixpenny Handley

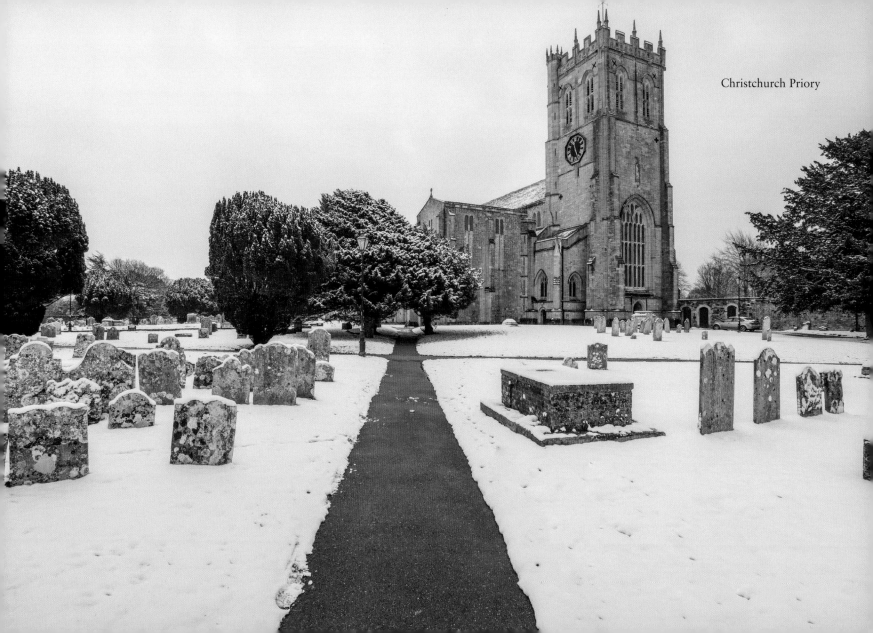
Christchurch Priory

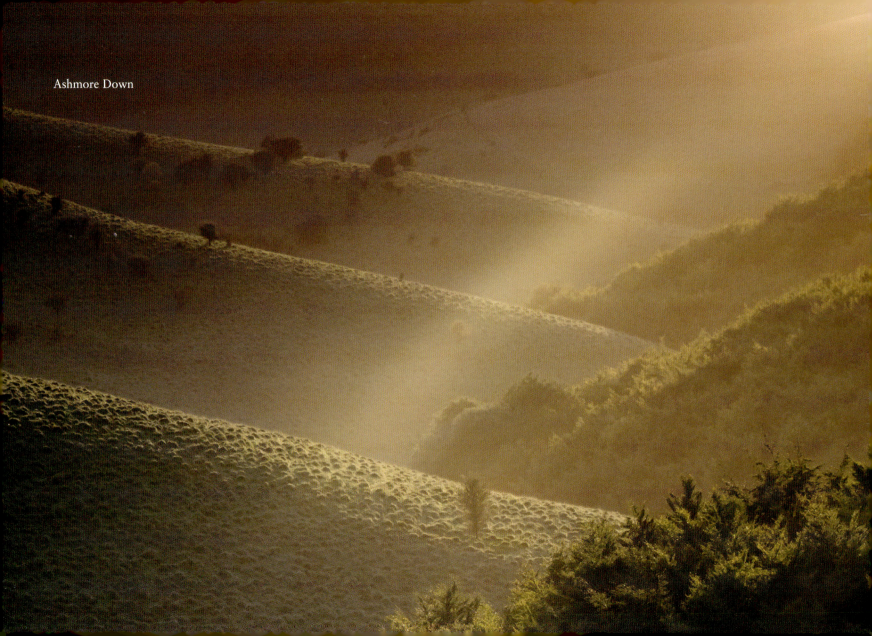
Ashmore Down

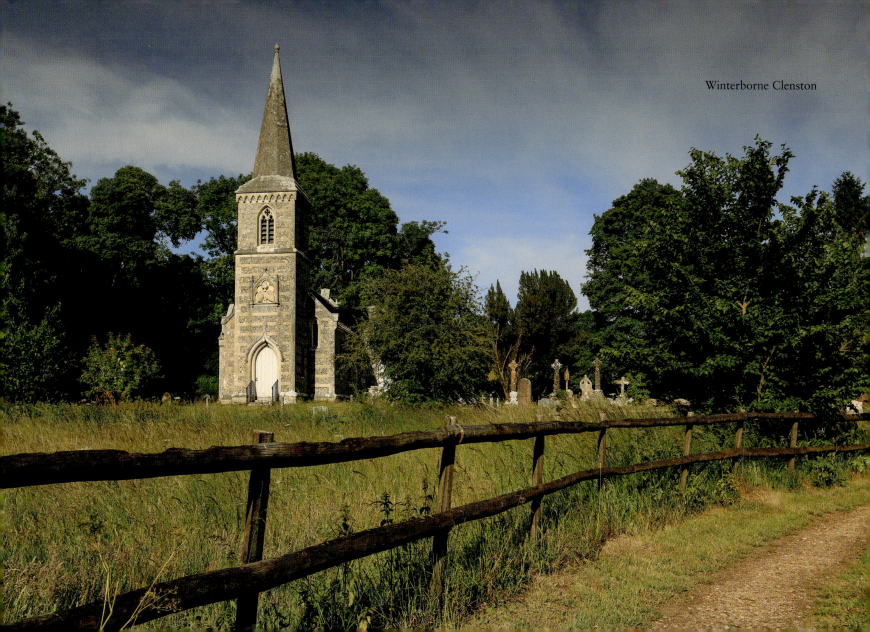
Winterborne Clenston

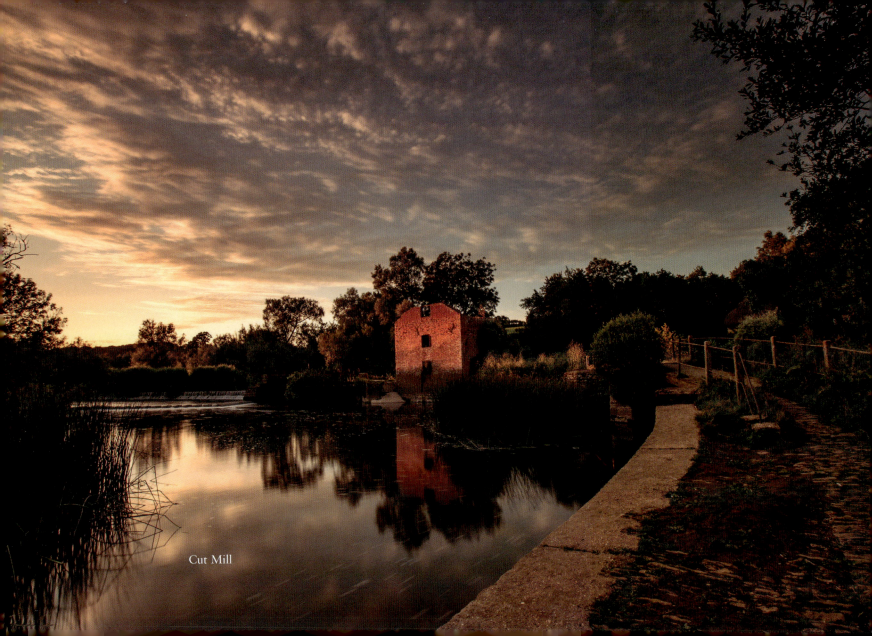
Cut Mill

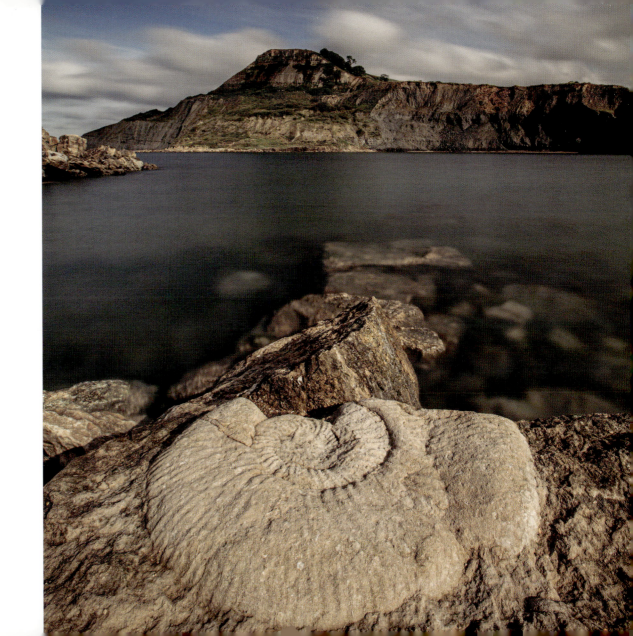

Chapmans Pool

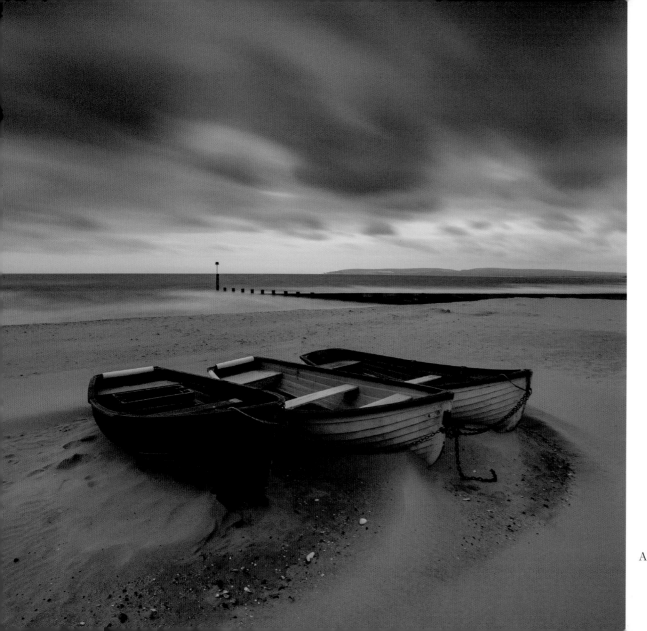

Alum Chine

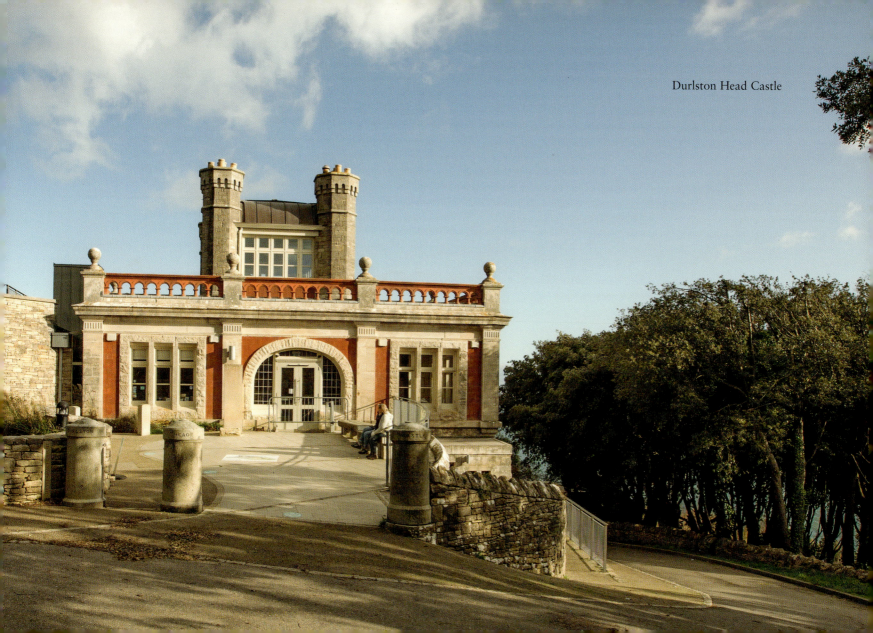
Durlston Head Castle

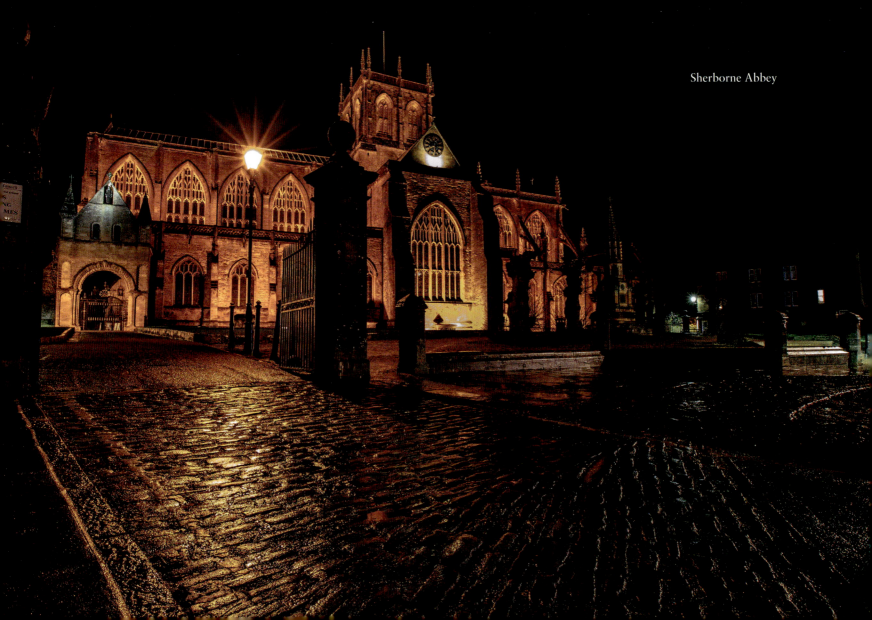

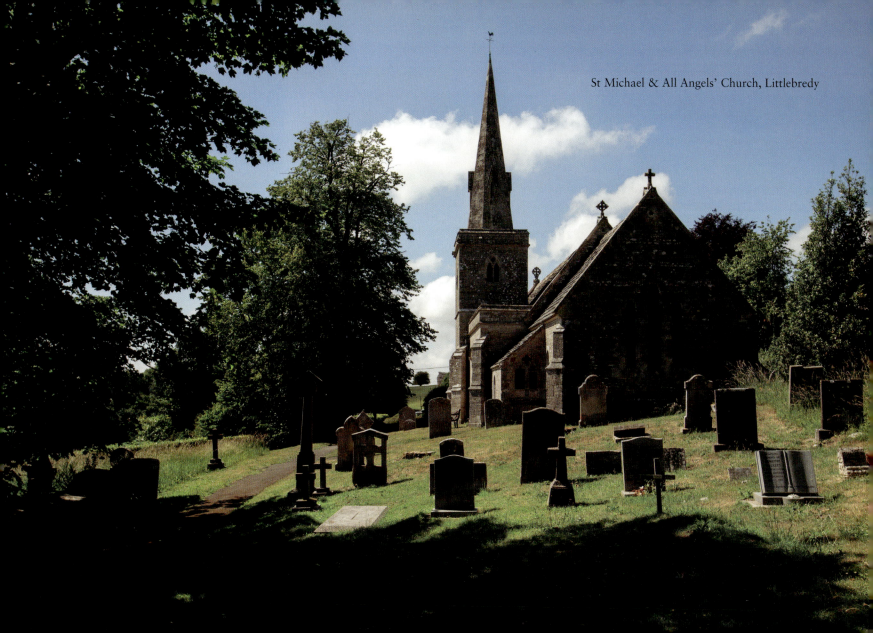
St Michael & All Angels' Church, Littlebredy

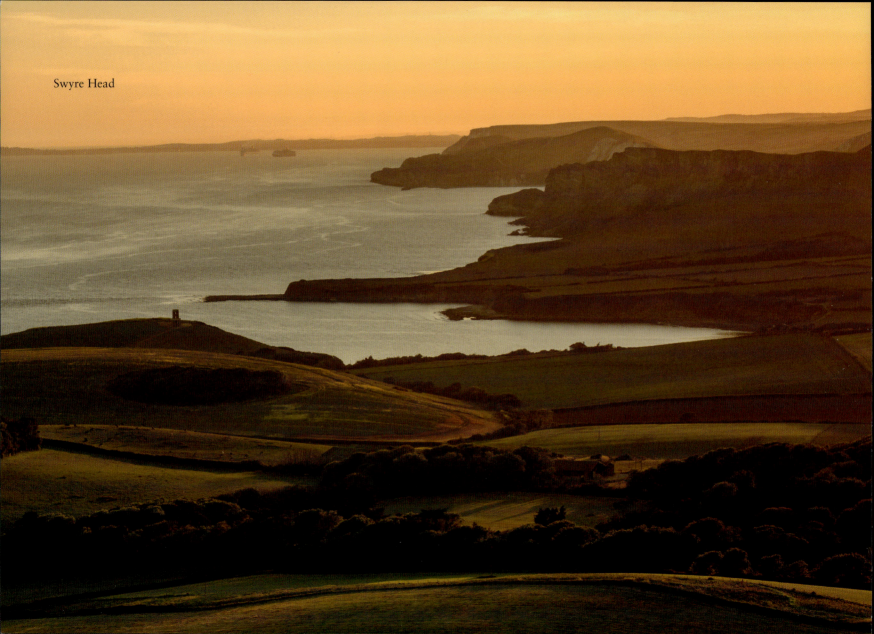
Swyre Head

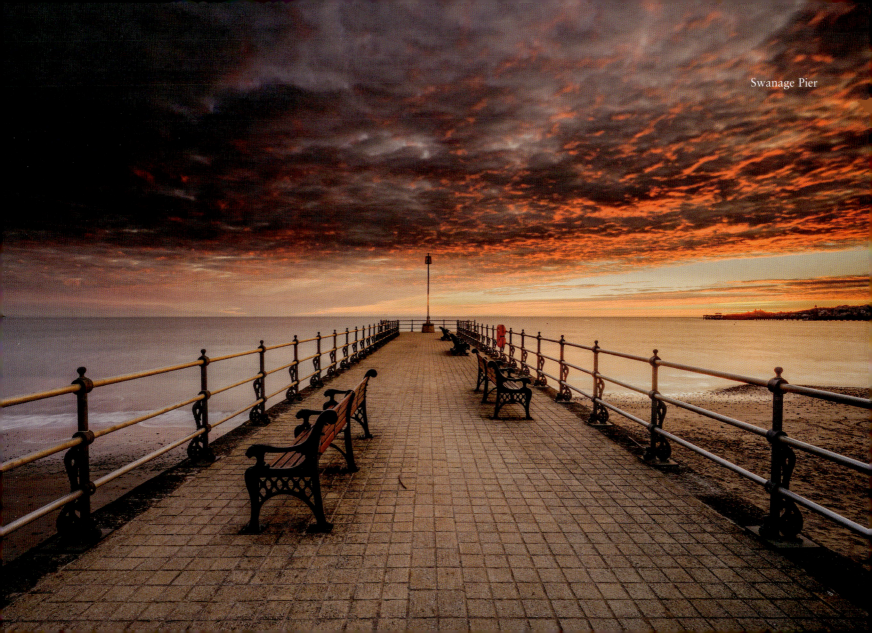
Swanage Pier

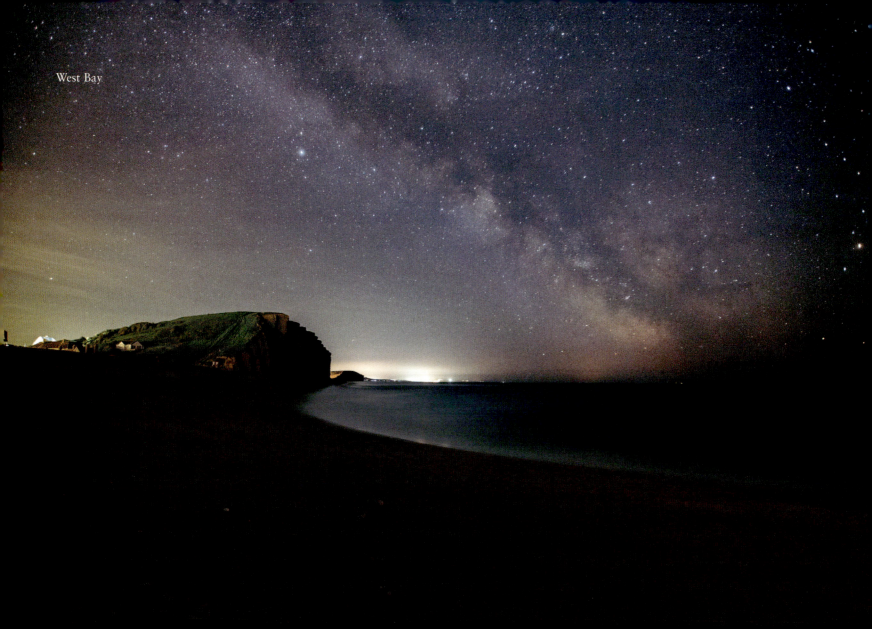
West Bay

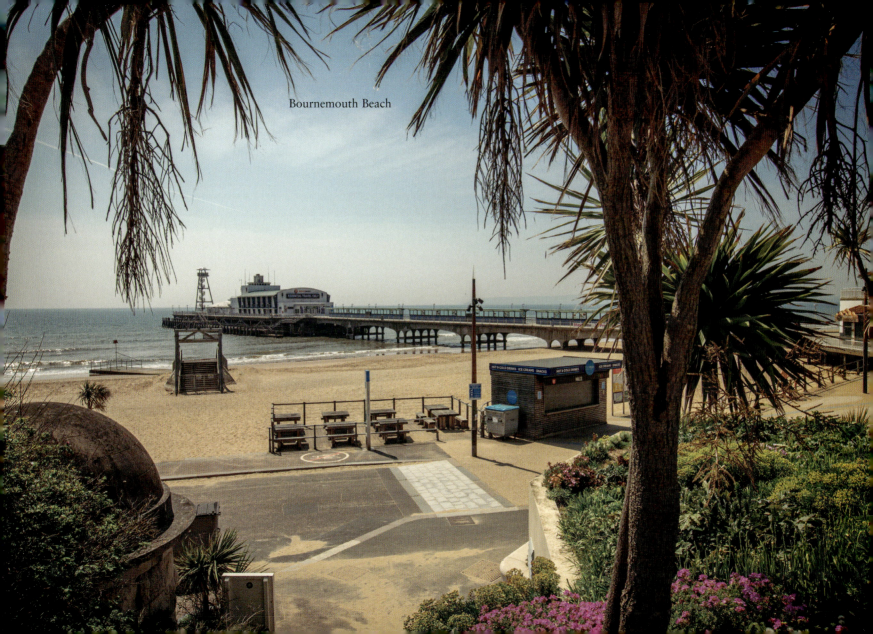
Bournemouth Beach

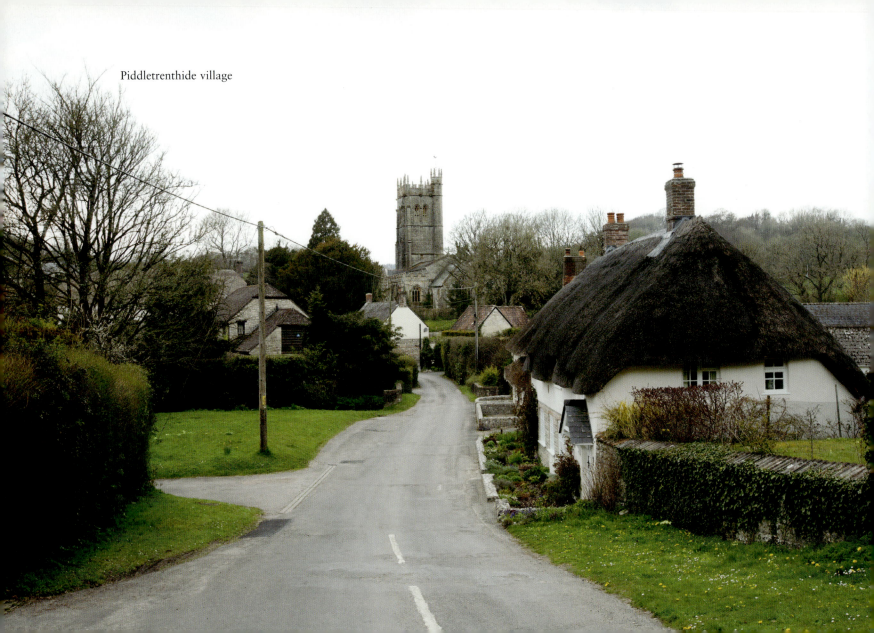
Piddletrenthide village

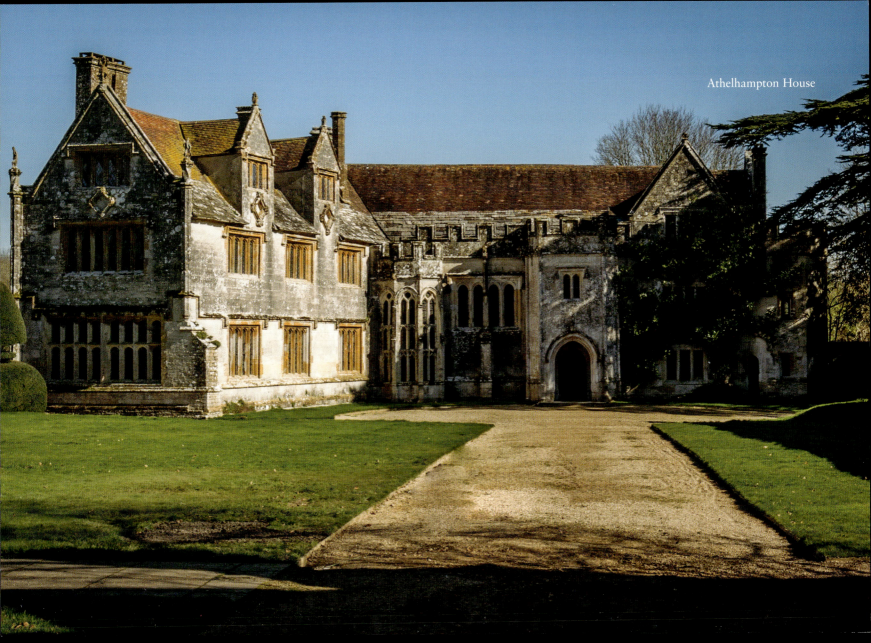
Athelhampton House

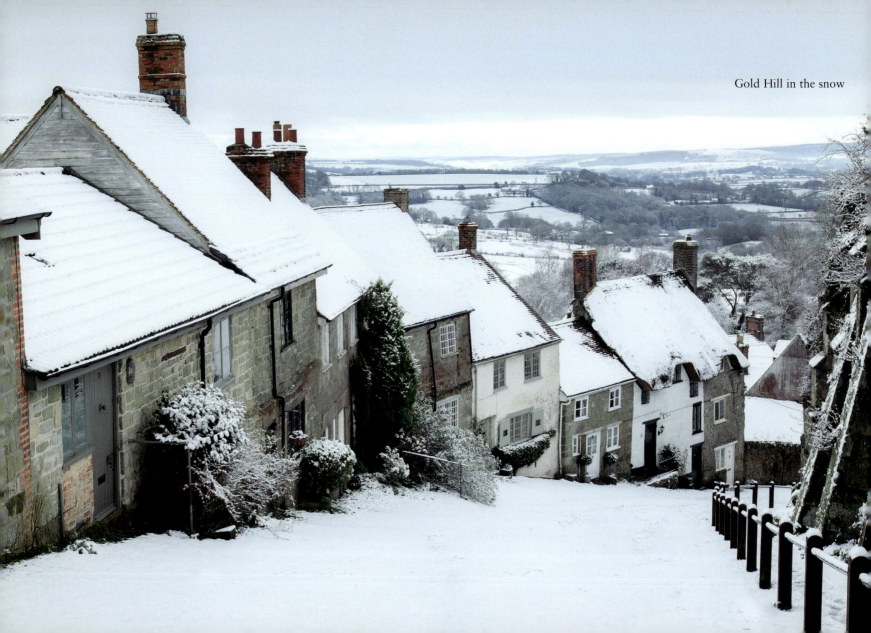

Gold Hill in the snow

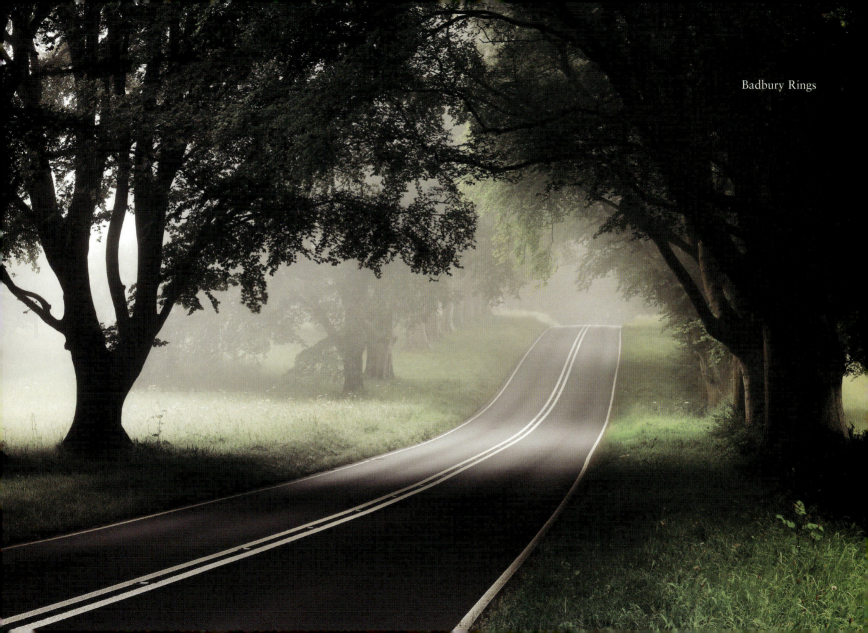
Badbury Rings

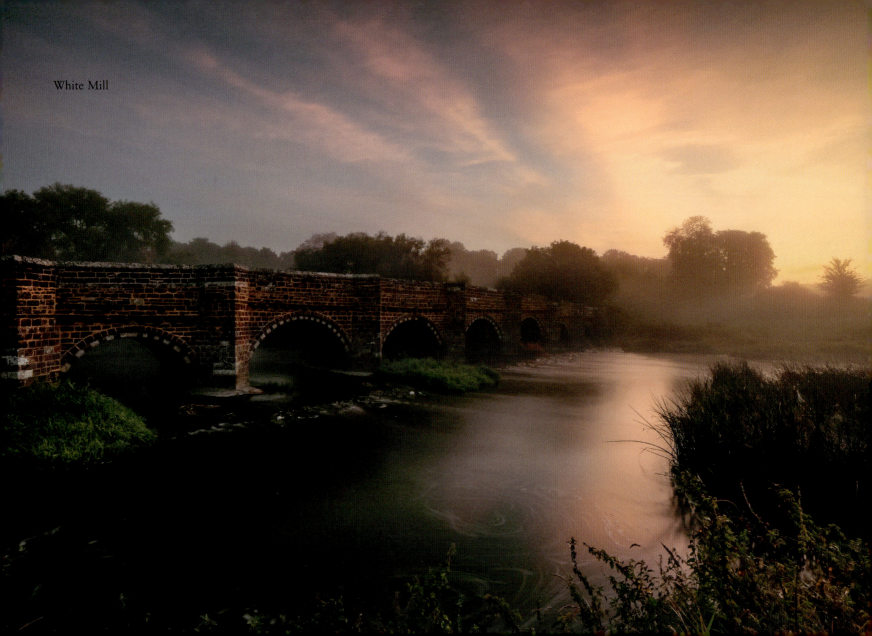
White Mill

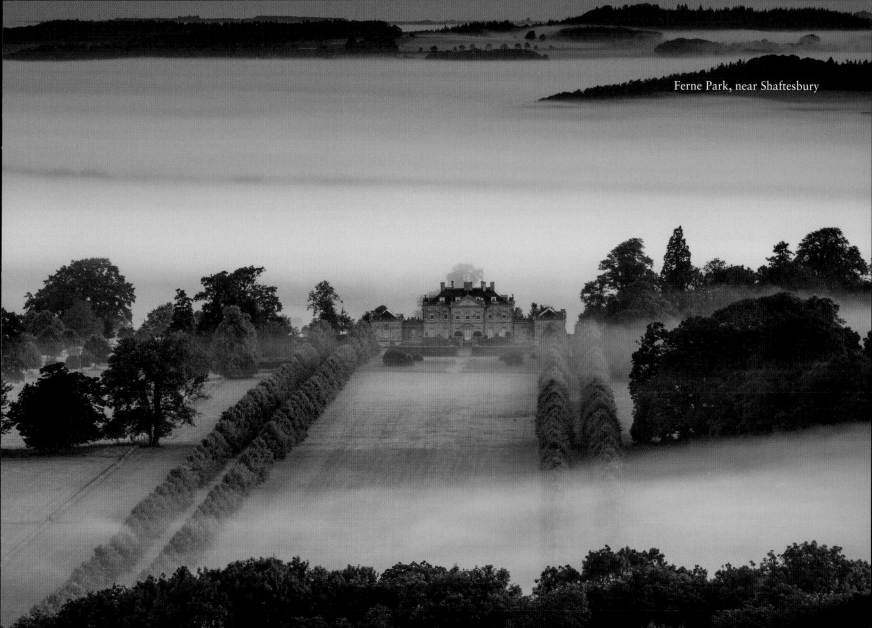
Ferne Park, near Shaftesbury

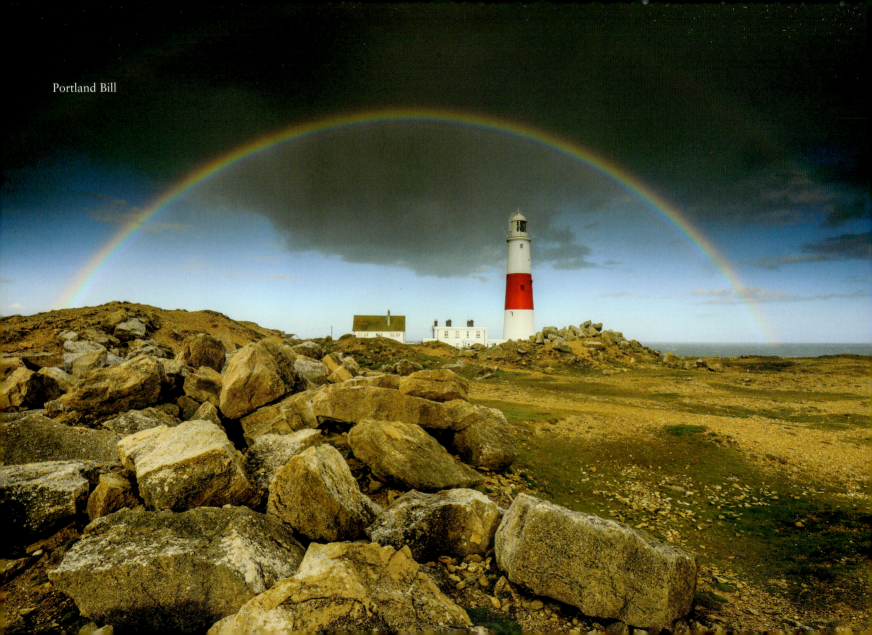
Portland Bill

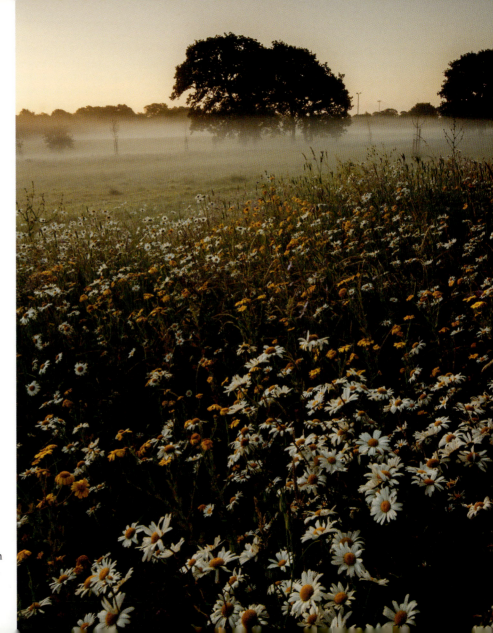

Tuckton, Christchurch

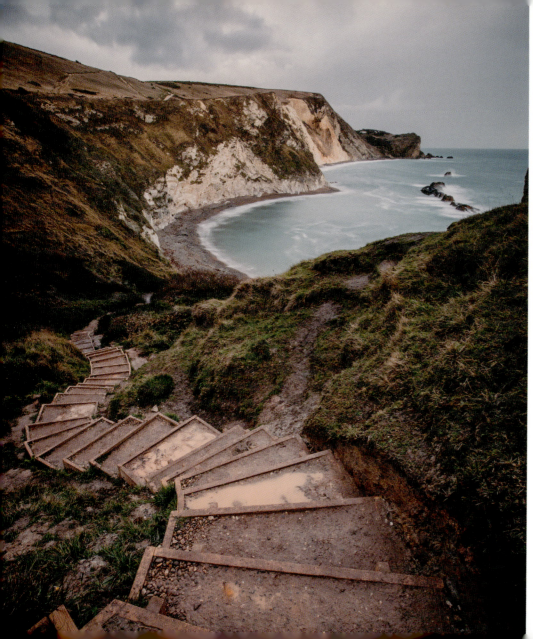

Steps to Man O'War Bay

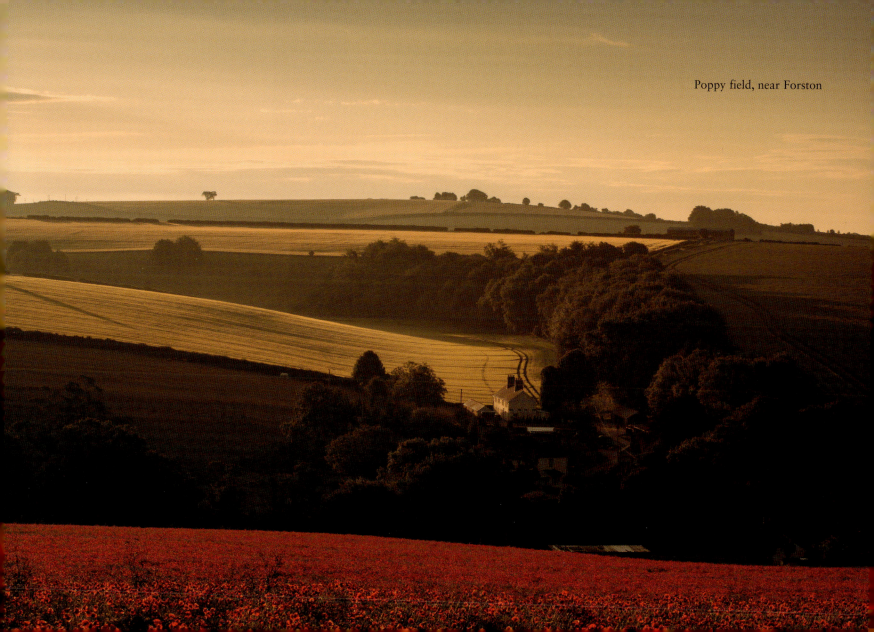

Poppy field, near Forston

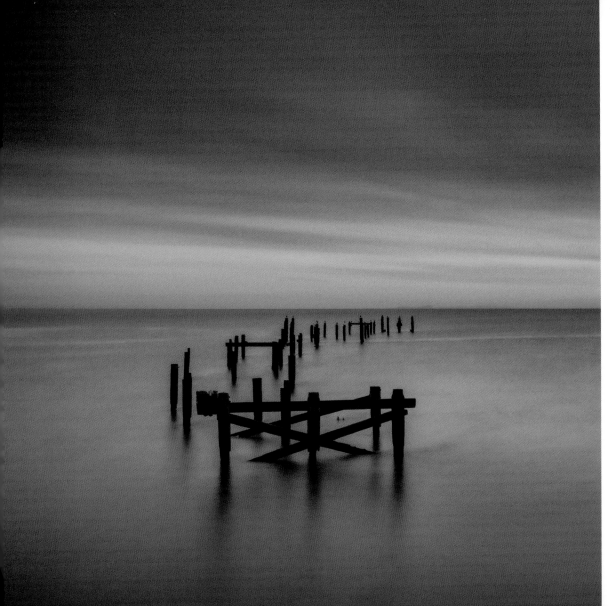

Old Swanage Pier

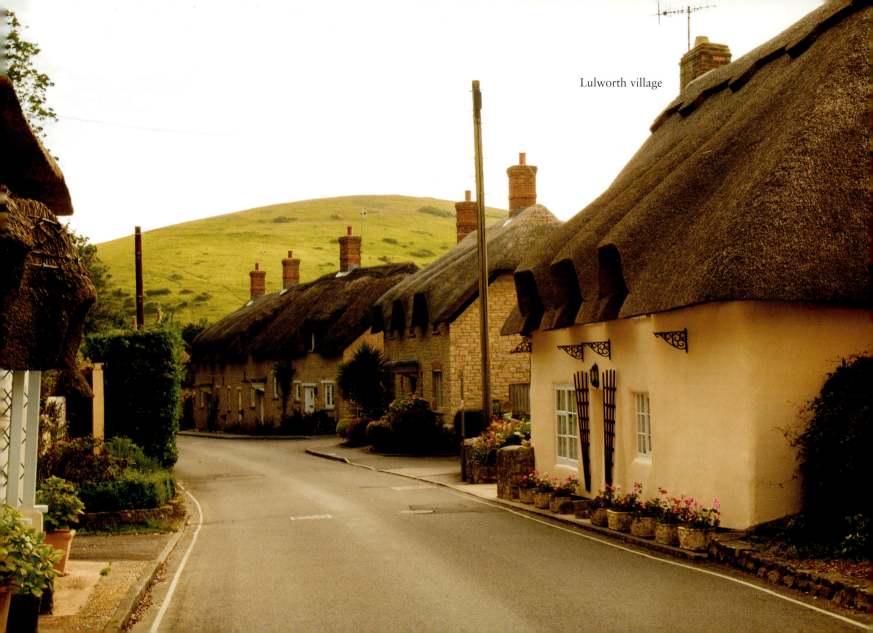
Lulworth village

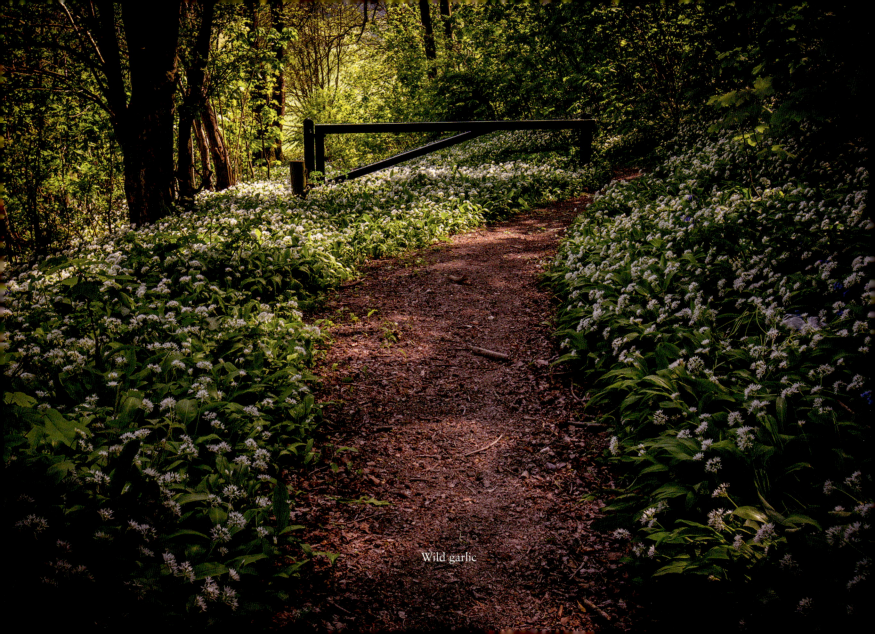

Wild garlic

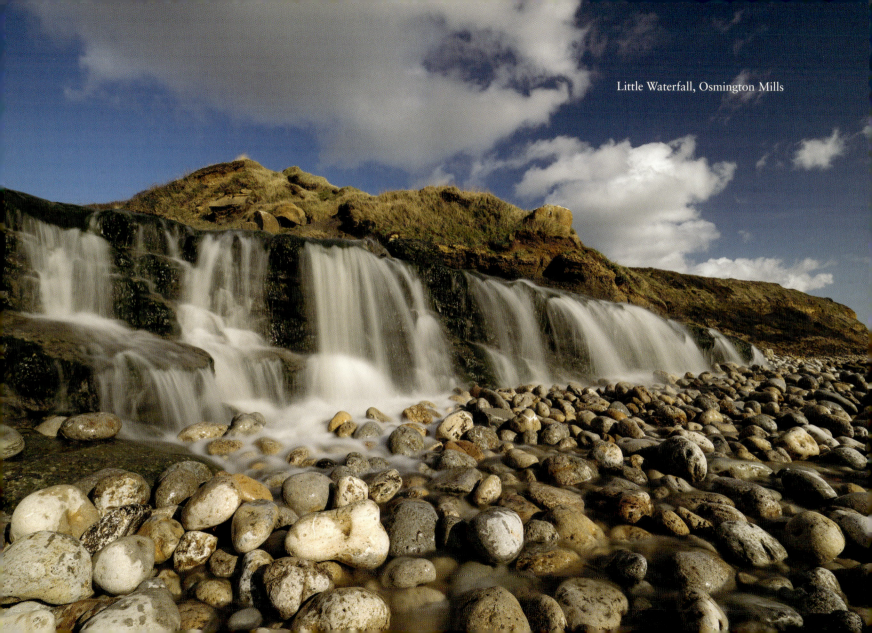
Little Waterfall, Osmington Mills

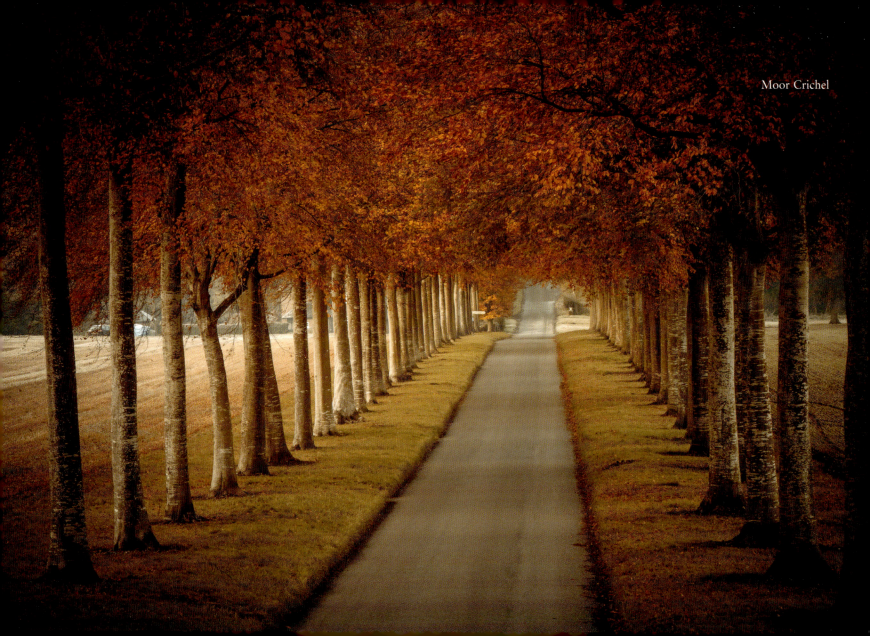

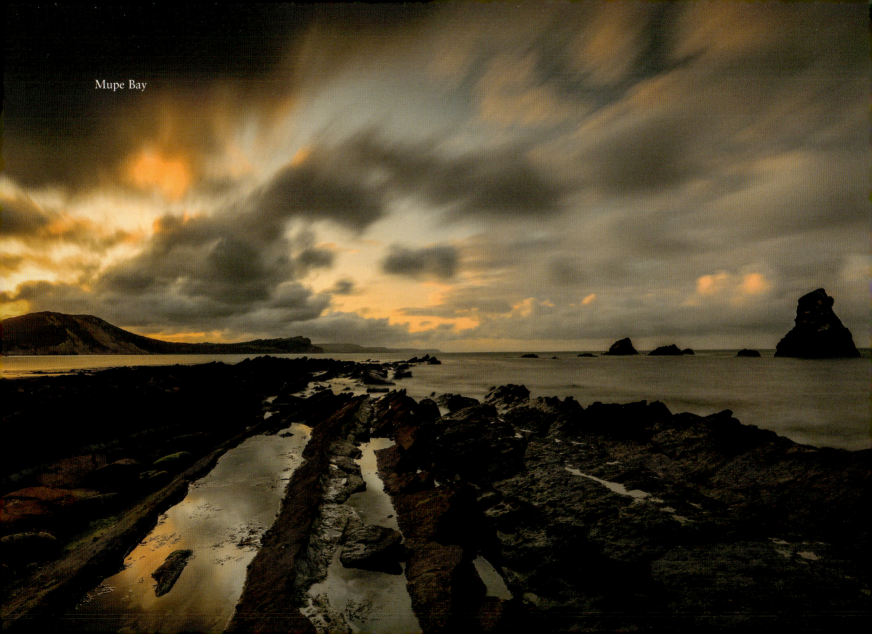
Mupe Bay

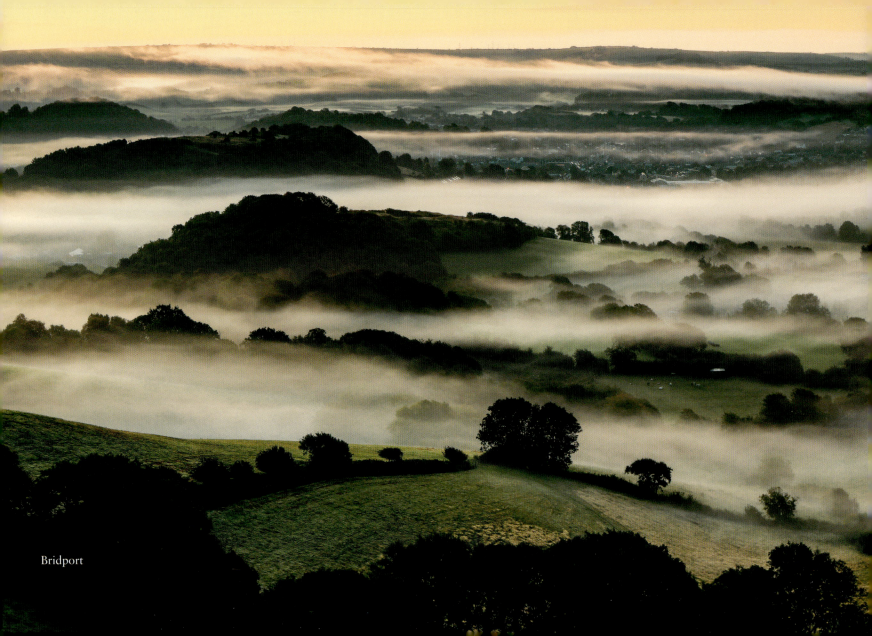
Bridport

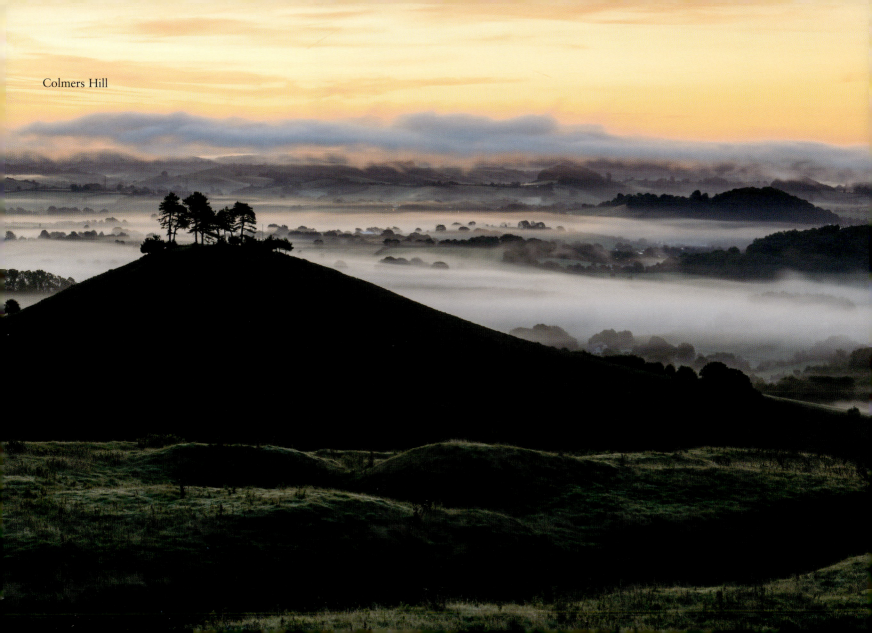
Colmers Hill

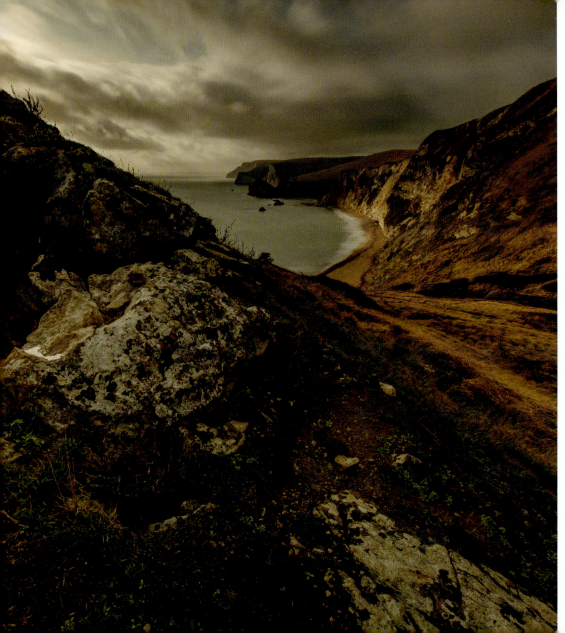

Dungy Head

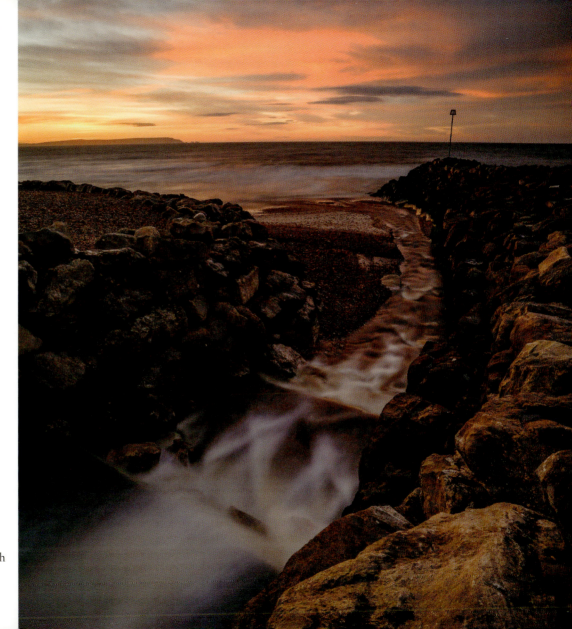

Highcliffe Beach

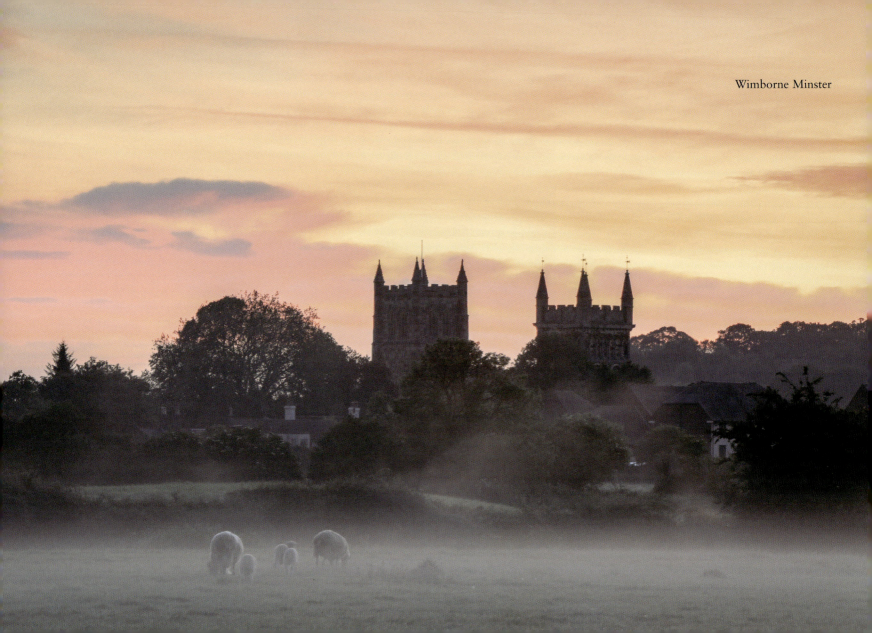
Wimborne Minster

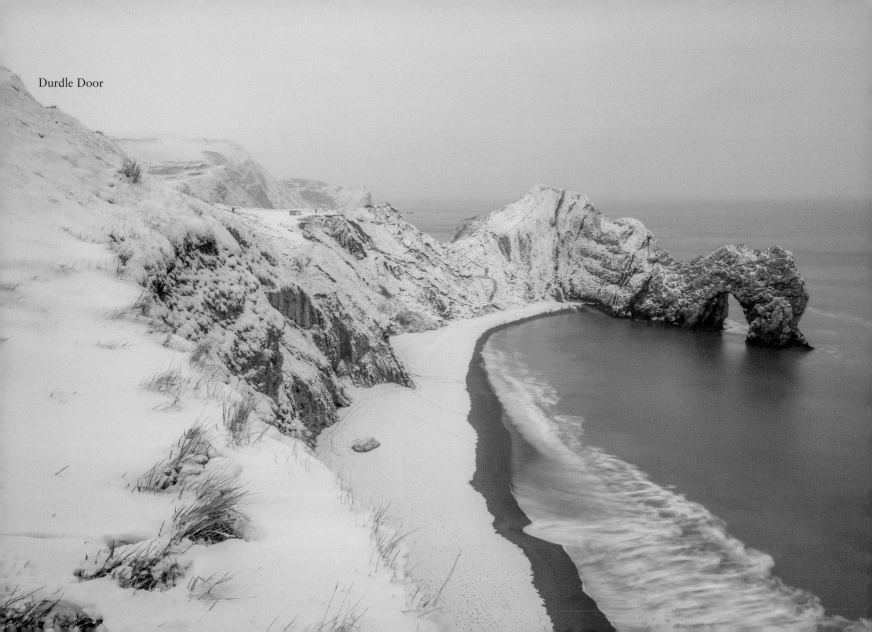

Durdle Door

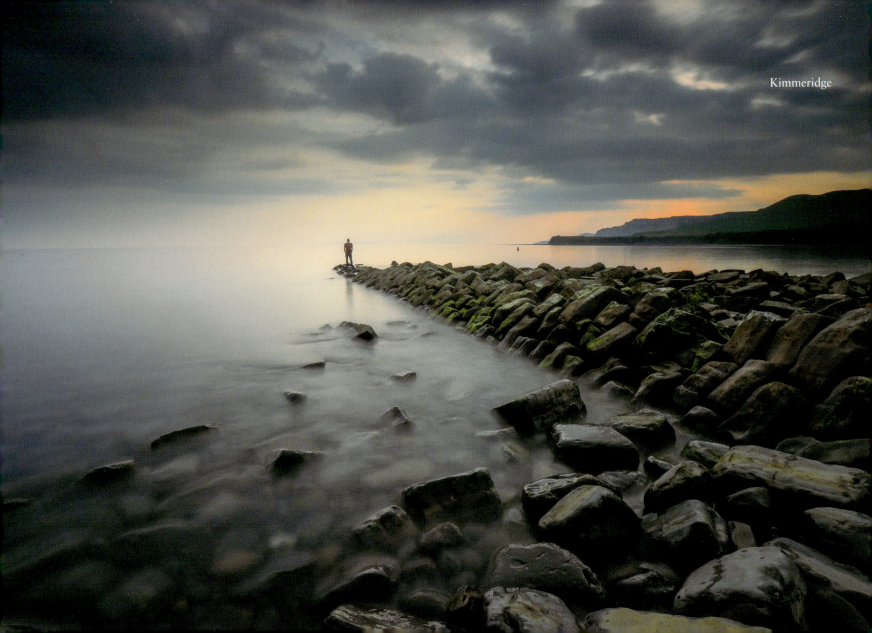
Kimmeridge

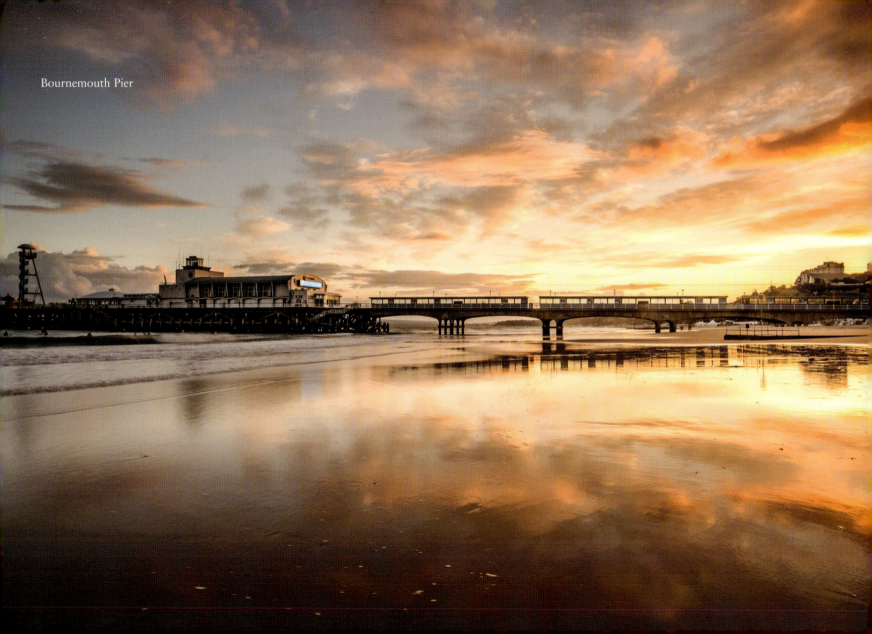
Bournemouth Pier

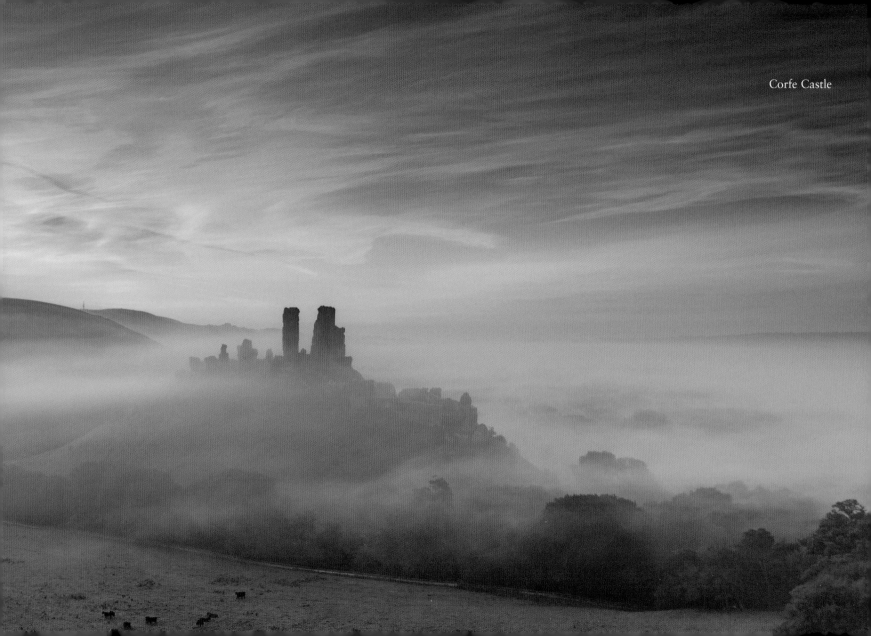

Corfe Castle

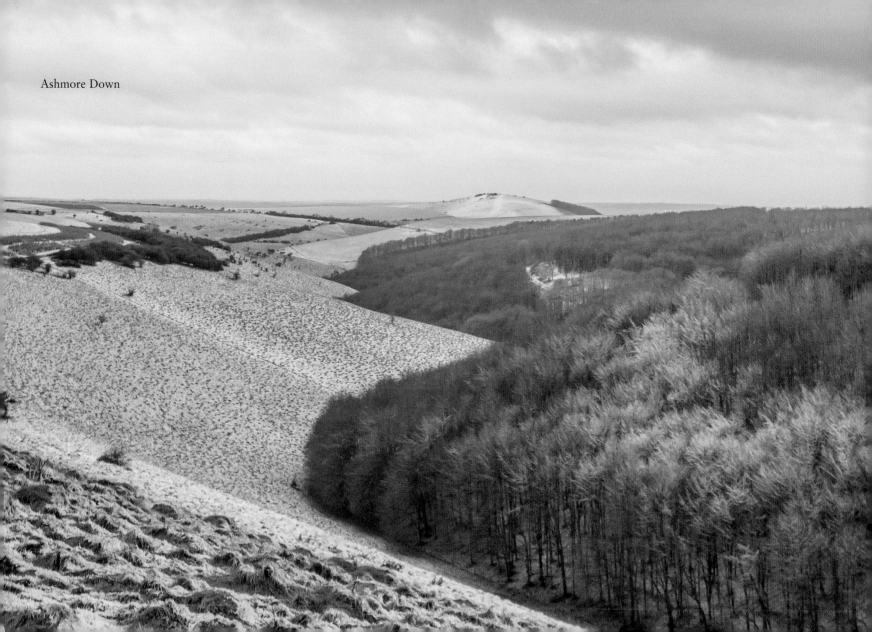
Ashmore Down

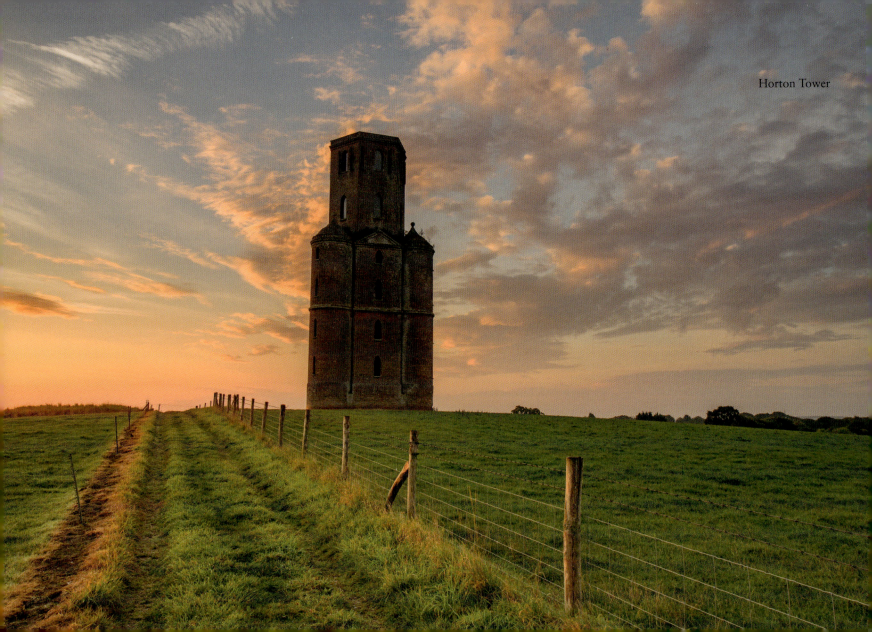
Horton Tower

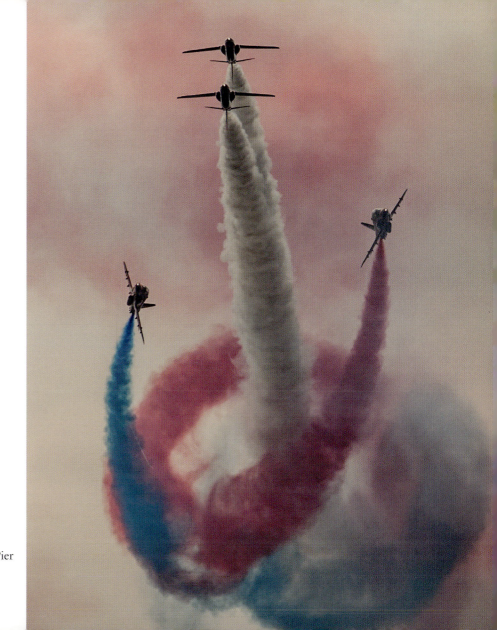

Air show at Bournemouth Pier

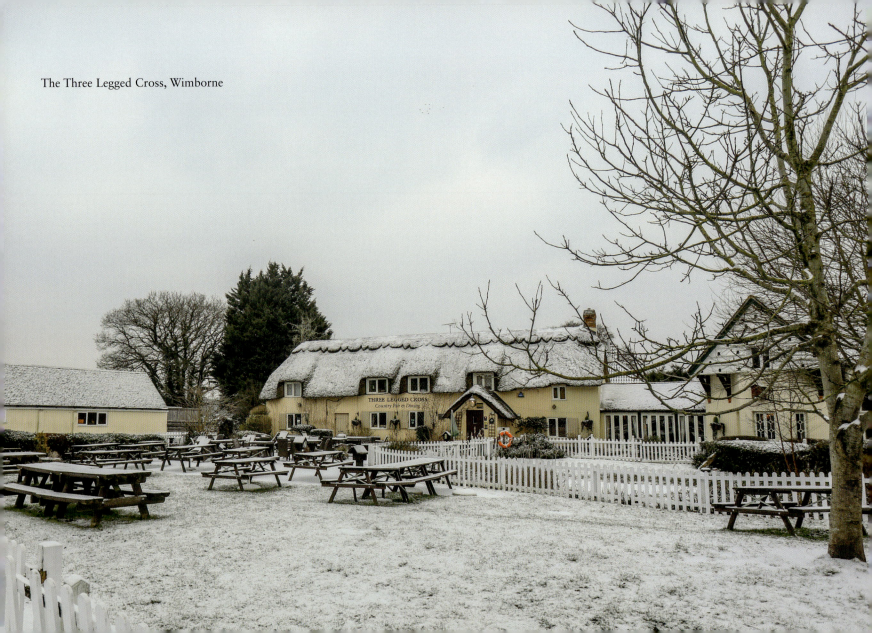
The Three Legged Cross, Wimborne

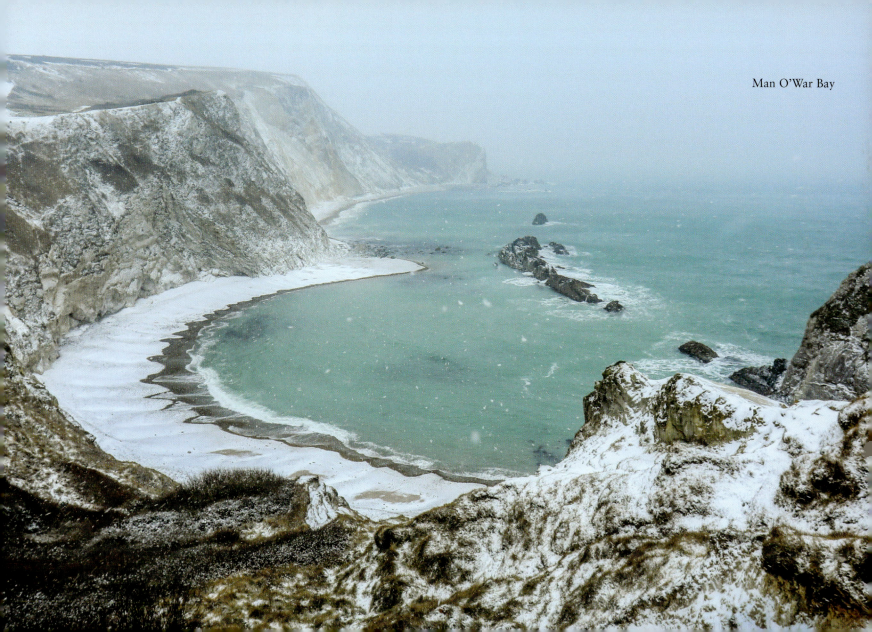
Man O'War Bay

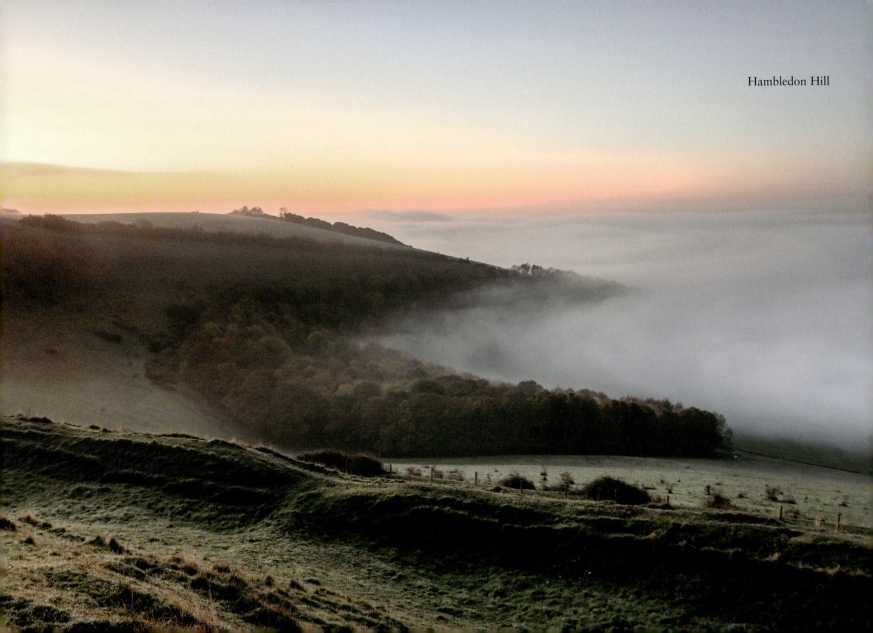
Hambledon Hill

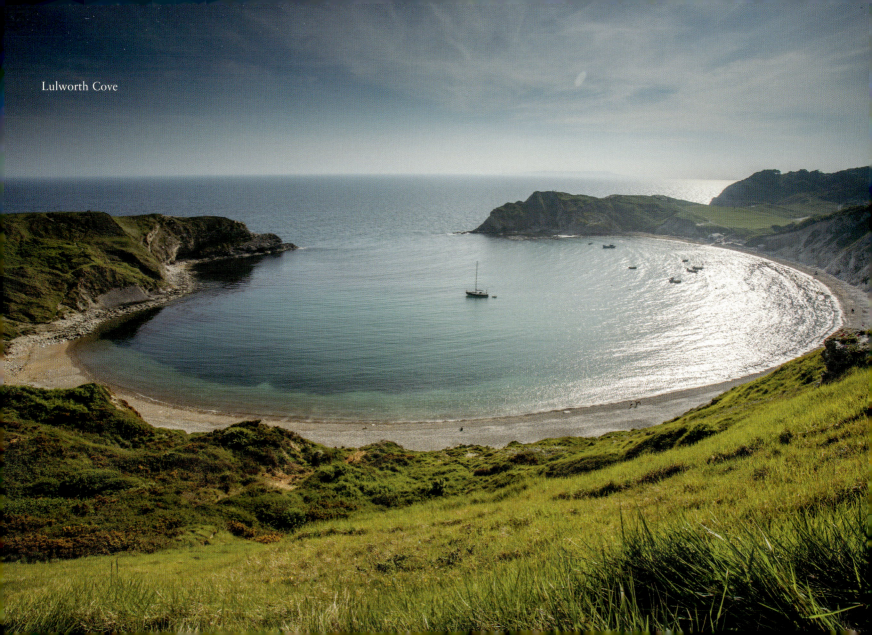
Lulworth Cove

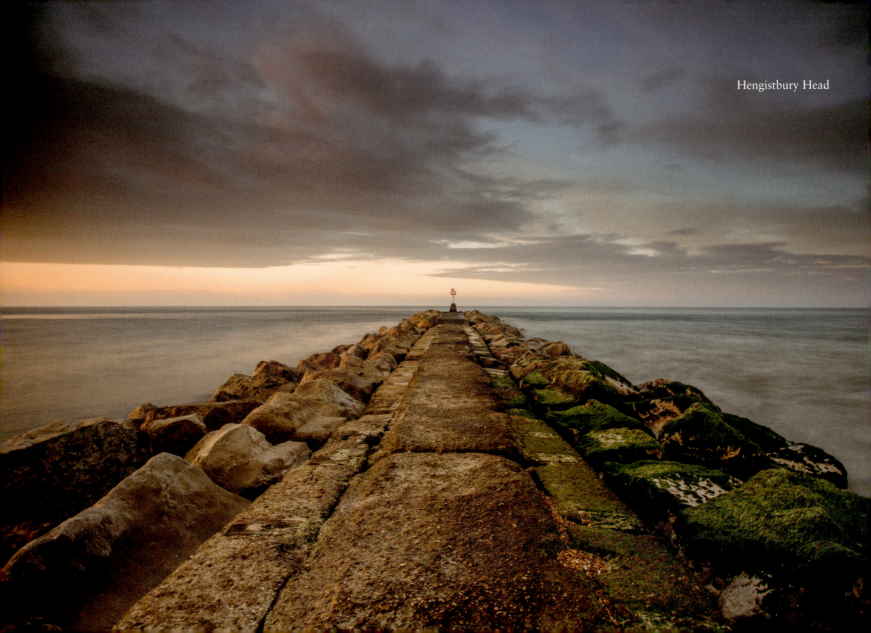
Hengistbury Head

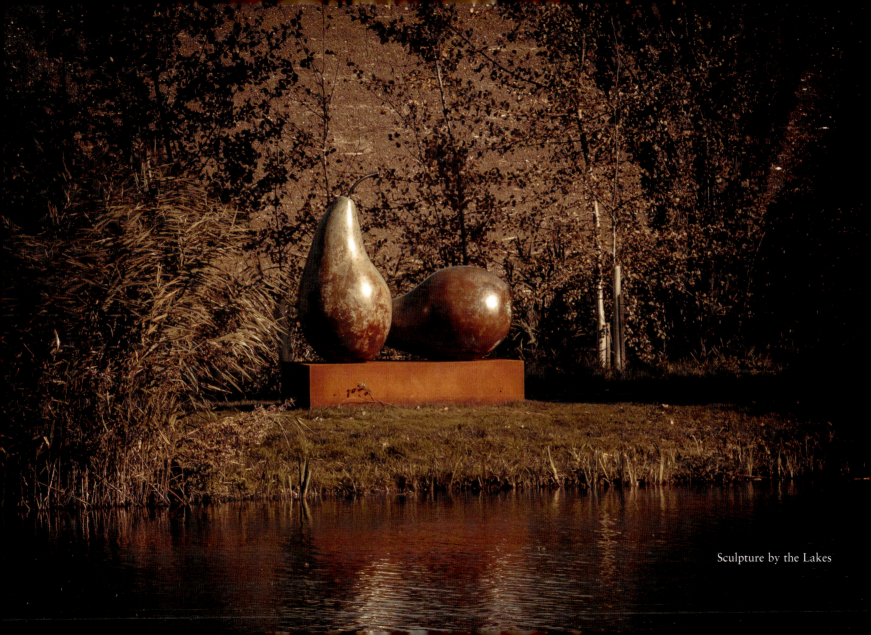
Sculpture by the Lakes

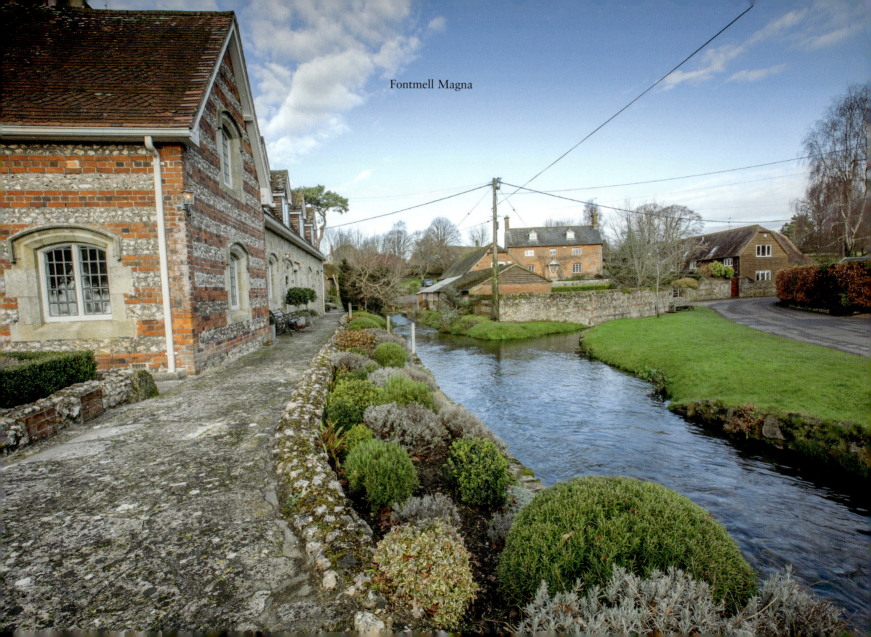
Fontmell Magna

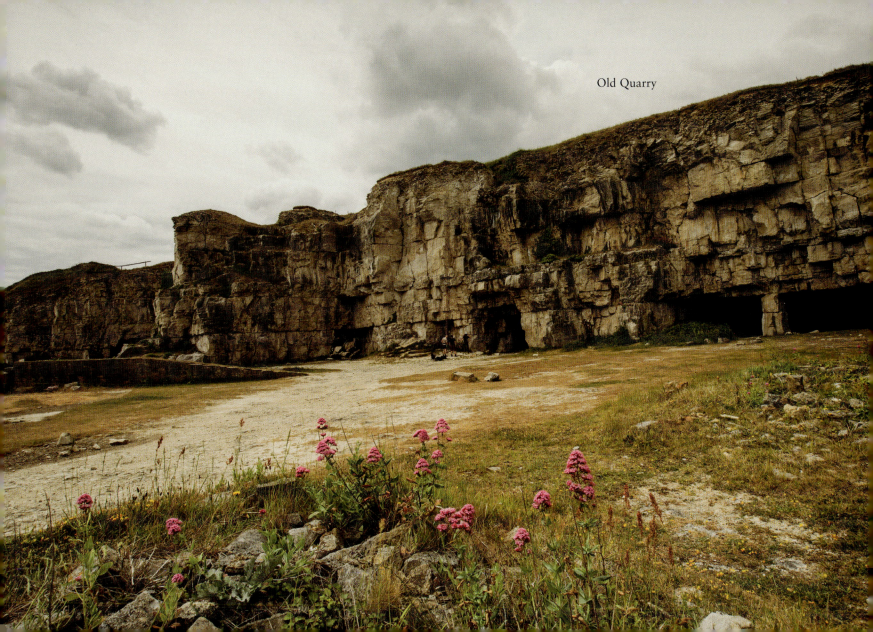
Old Quarry

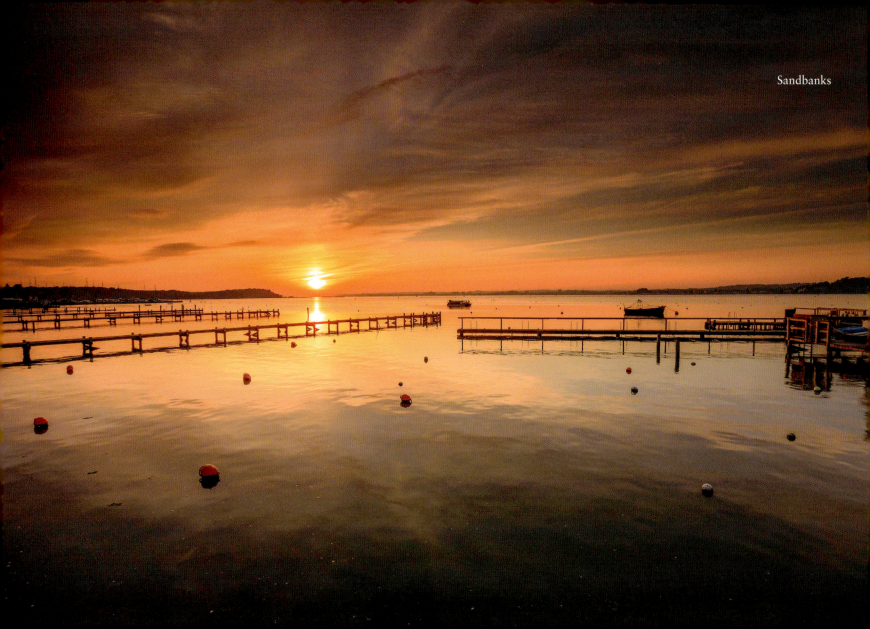

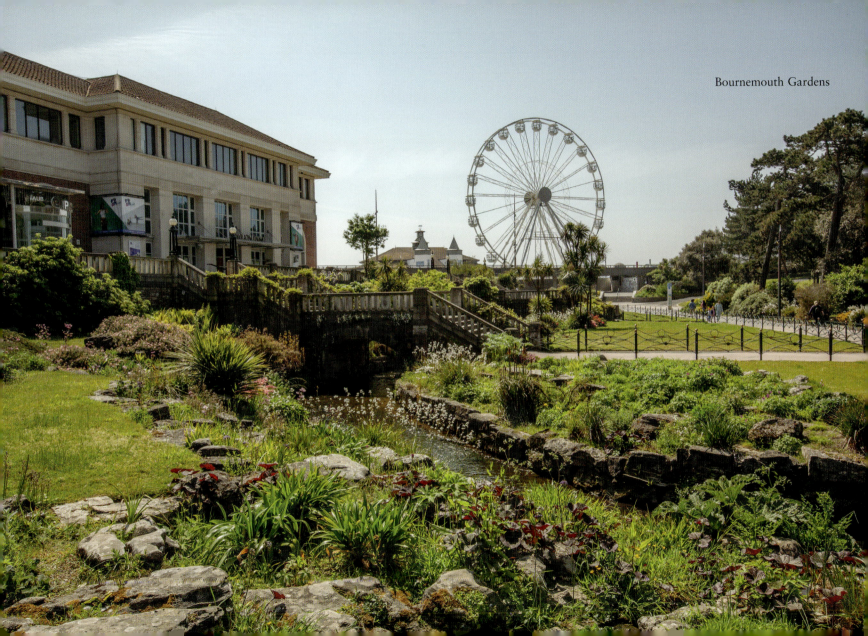
Bournemouth Gardens

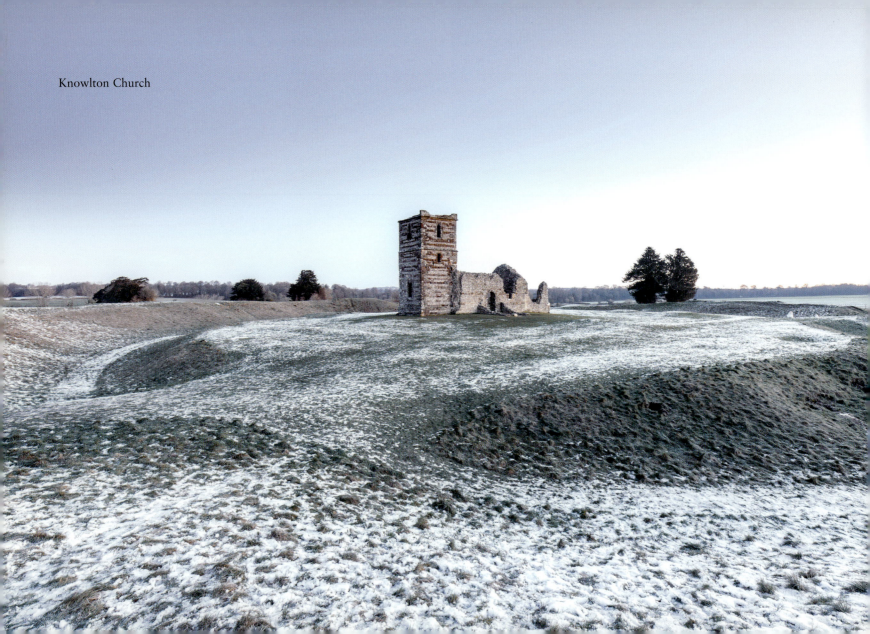
Knowlton Church

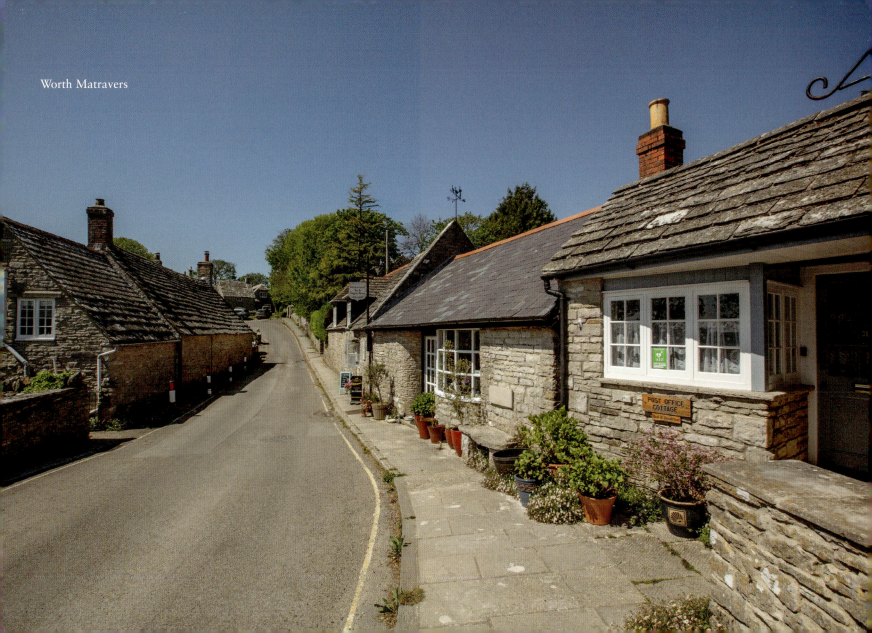
Worth Matravers

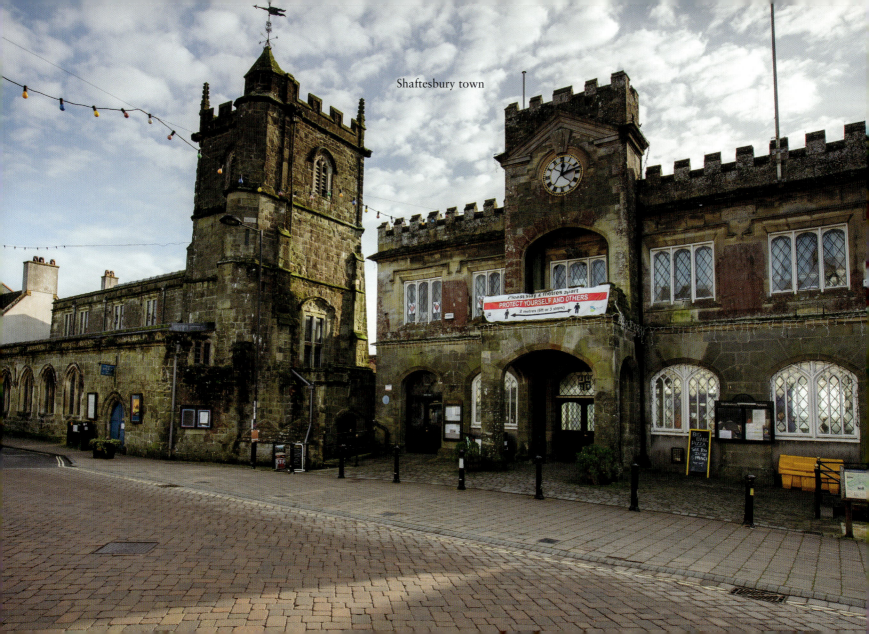
Shaftesbury town

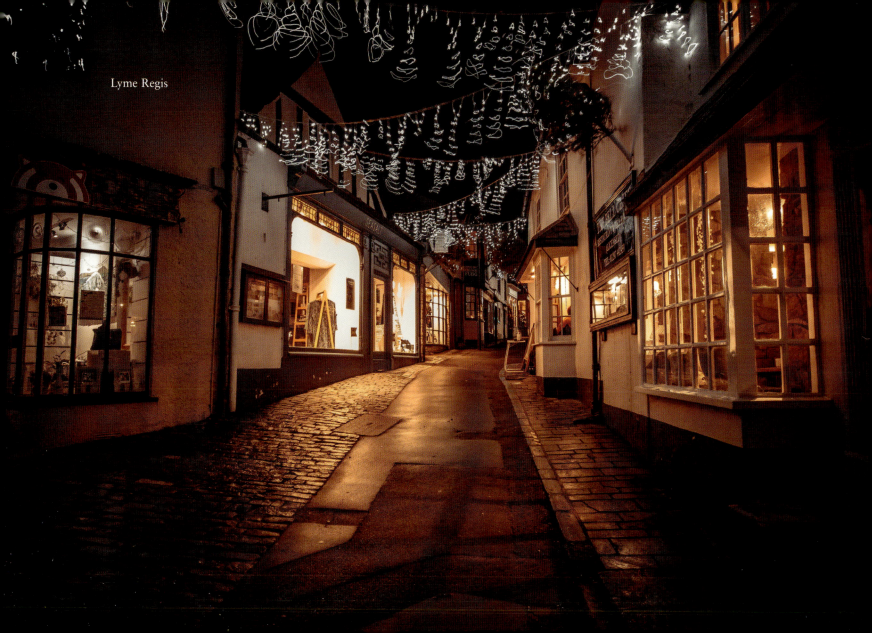
Lyme Regis

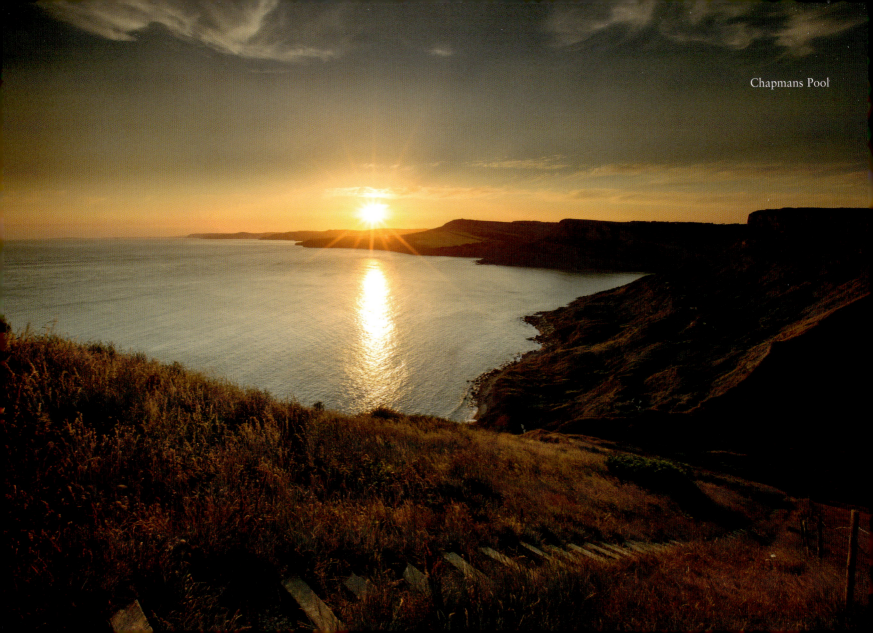
Chapmans Pool

Stair Hole

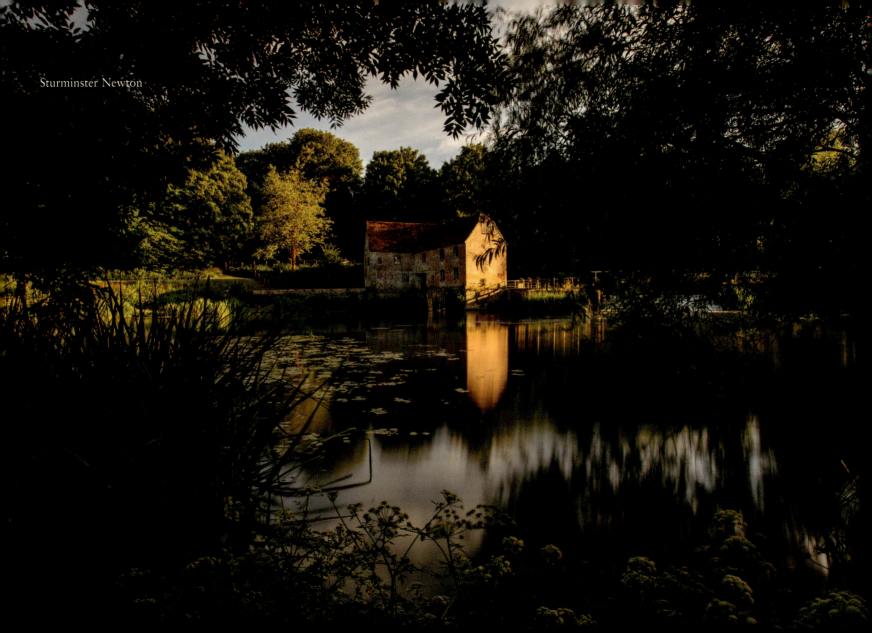
Sturminster Newton

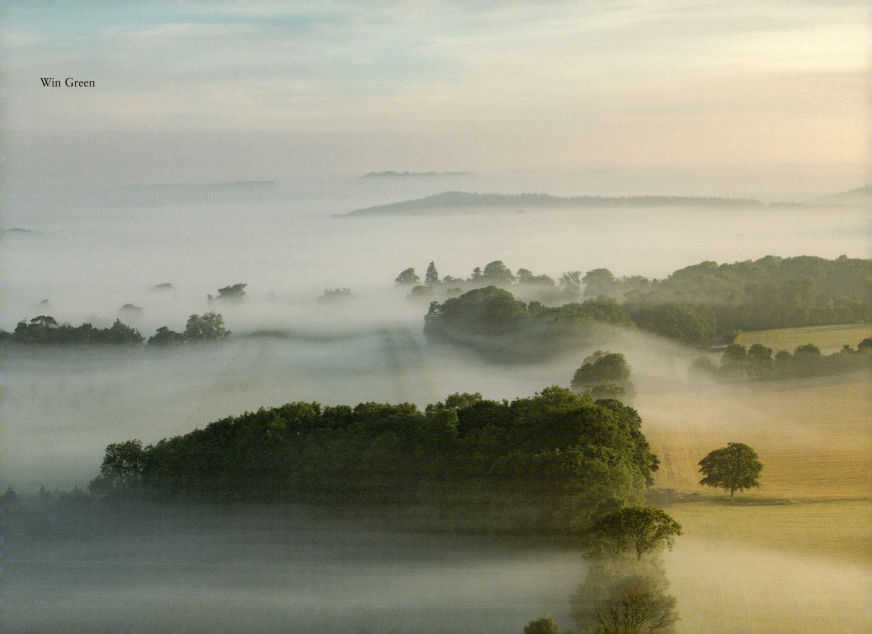
Win Green

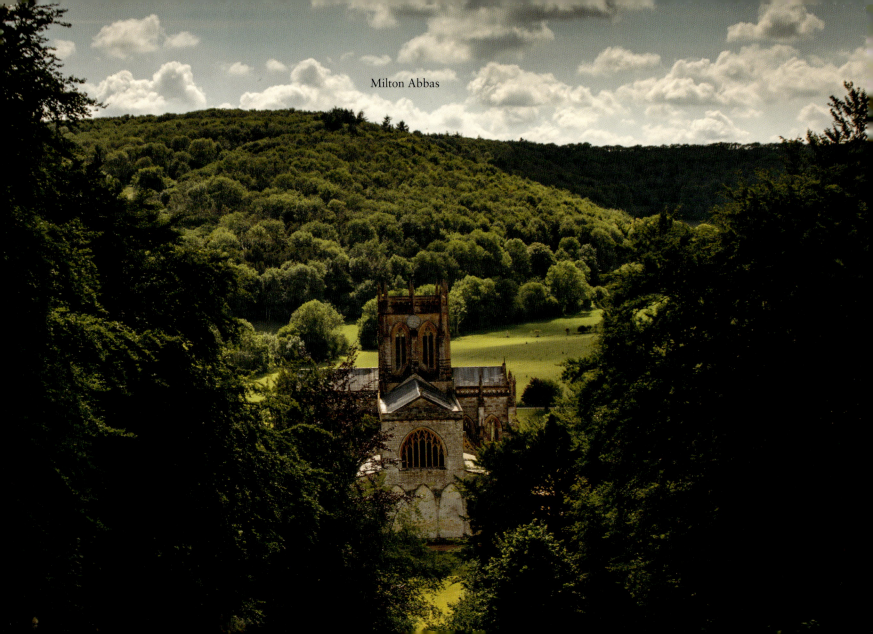
Milton Abbas

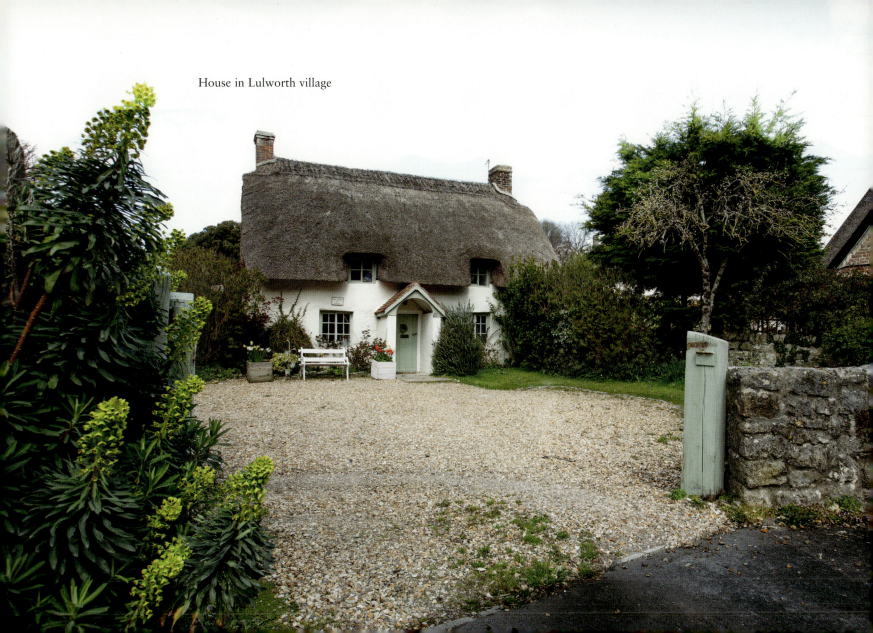
House in Lulworth village

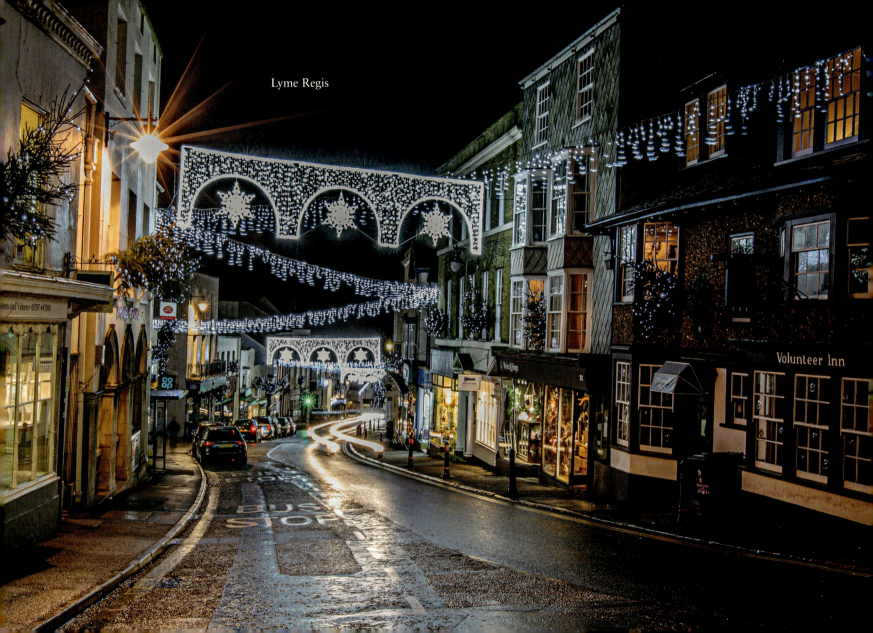

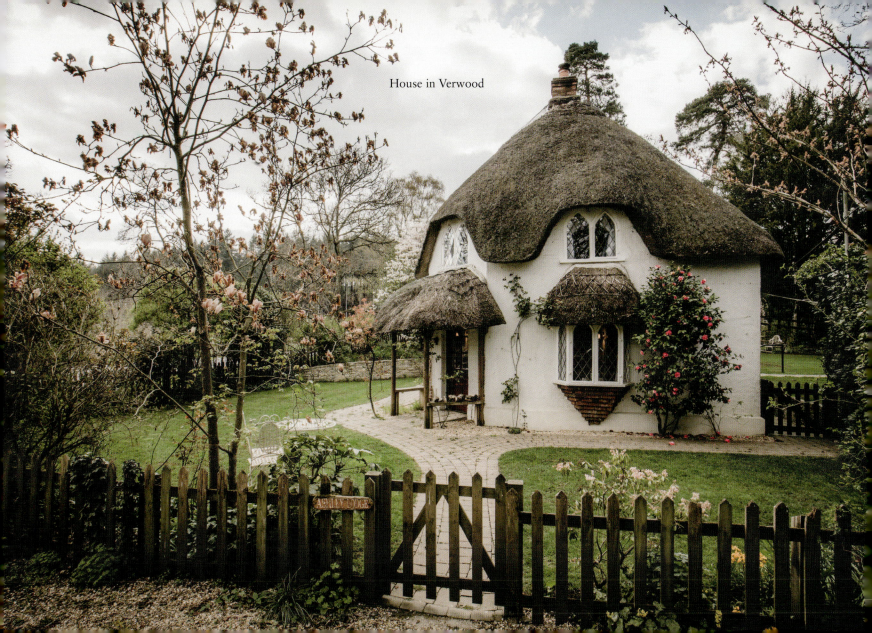
House in Verwood

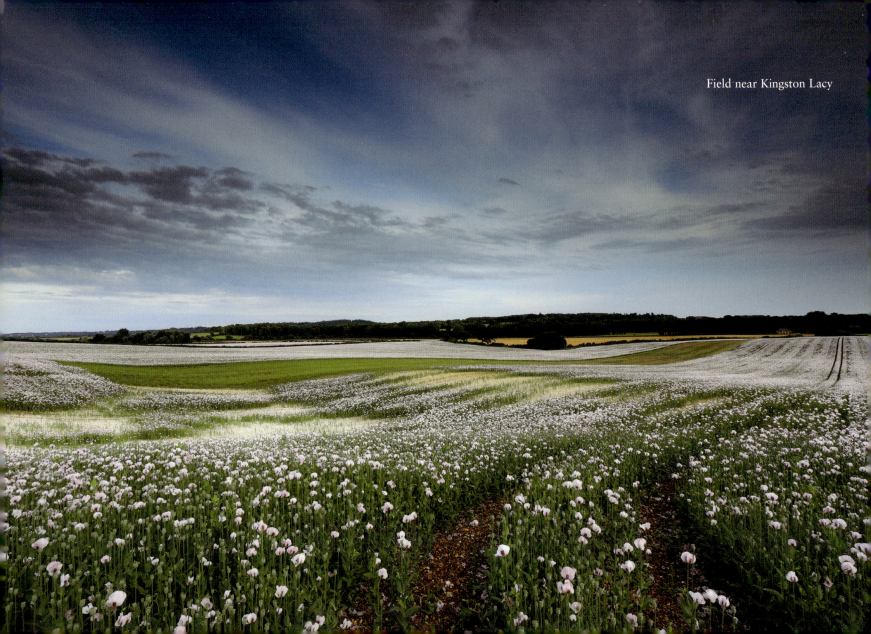
Field near Kingston Lacy

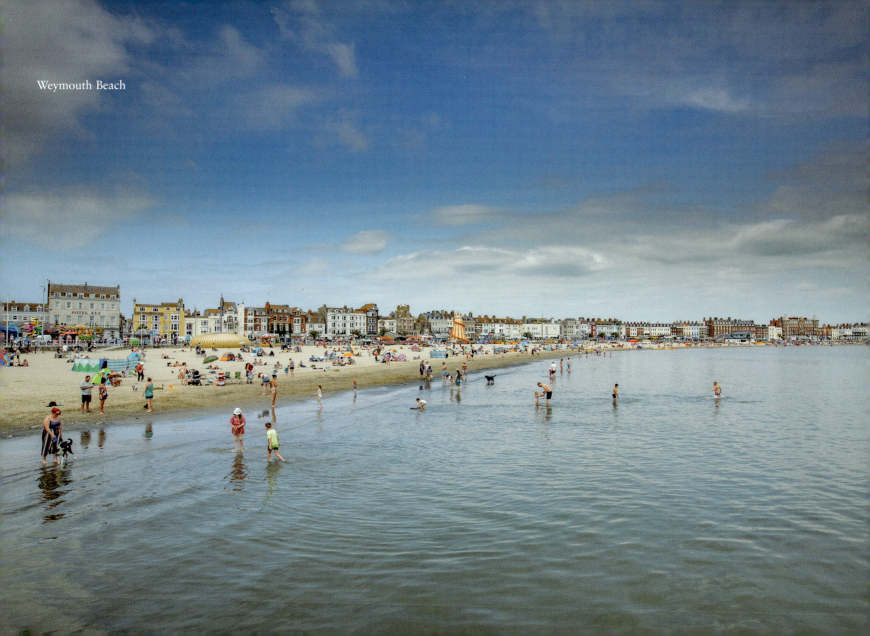

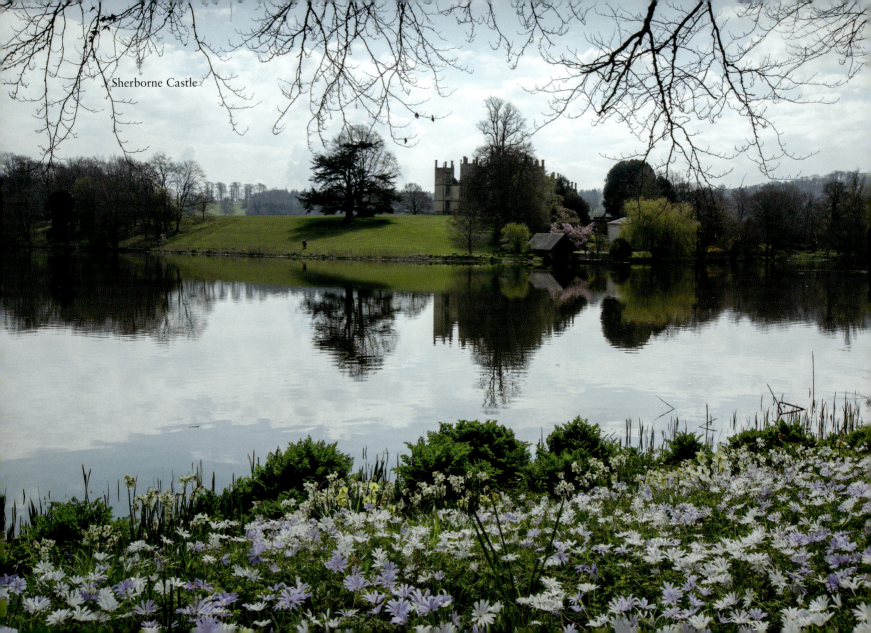
Sherborne Castle